Ashmolean handbooks

Poussin to Cézanne

French drawings and watercolours

in the Ashmolean Museum

Jon Whiteley

Ashmolean Museum Oxford
in association with
The Wallace Collection London
2002

ISBN 1 85444 168 X (paperback)
ISBN 1 85444 169 8 (papercased)

Titles in this series include:
The Ashmolean Museum
Ruskin's drawings
Worcester porcelain
Maiolica
Drawings by Michelangelo and Raphael
Oxford and the Pre-Raphaelites
Islamic ceramics
Indian paintings from Oxford collections
Camille Pissarro and his family
Eighteenth-century French porcelain
Miniatures
Samuel Palmer
Twentieth century paintings
Ancient Greek pottery
English Delftware
J. M. W. Turner
Glass of four millennia
Finger rings ancient to modern
Picture frames

British Library Cataloguing in Publication Data
A catalogue record for this book is available from the
British Library

A · H · R · B
arts and humanities research board

Cover illustration: Edouard Manet, *Lunch on the Grass* (no. 48)

Designed and typeset in Versailles by Roy Cole, Wells
Printed in England by BAS Printers Limited, Hampshire

Preface

The Print Room of the Ashmolean Museum is known throughout the world for its Italian and English drawings but it also holds outstanding collections of Netherlandish and French drawings. The French drawings have been for many years in the care of Jon Whiteley, whose detailed catalogue of almost 1500 drawings appeared in 2000. It represents the distillation of a lifetime's study of French draughtsmanship. Jon Whiteley has made a selection of those drawings which are to be shown in a special exhibition at the Wallace Collection in London from January until April 2002. To accompany that exhibition and to serve as an introduction to the rich collection of French drawings in the Ashmolean, he has written this handbook in which fifty-two drawings are discussed and illustrated. I am enormously grateful to Jon Whiteley, one of the leading scholars in the area of French art, who has not only catalogued this collection with great distinction but – as the dates of acquisition will reveal – has been instrumental in acquiring a number of these drawings for the Museum.

A publication like this requires the help of many scholars – so many that it would be difficult to acknowledge them all. We are particularly grateful to those who have given direct help with entries and whose names are concealed behind the phrase 'it has recently been pointed out', namely: Louise Rice, Jean-Christophe Baudequin, Jean-Claude Boyer, Judi Loach, Antoine Schnapper, Nelke Bartelings, Marianne Roland Michel, Colin Harrison, Pierre Rosenberg, Damien Bartoli and Juliet Wilson Bareau. Both the exhibition and this handbook have resulted from a successful collaboration between the Wallace Collection and the Ashmolean. We are grateful to our colleagues at the Wallace Collection for the original suggestion and to colleagues in the Ashmolean – in particular, Geraldine Glynn, Ian Charlton, and Alexander Newson – for their contributions. All the photographs were taken with customary skill by David Gowers. Above all, we are indebted to Katrin Henkel and to Jean Bonna for generously sponsoring both the exhibition and the handbook.

Dr Christopher Brown
Director

Introduction

The collection of French drawings in Oxford began
in 1834 with the bequest of Francis Douce. Douce
was an historian of popular culture who collected a
wide range of art and artefacts. French drawings
were only one part of his bequest – now divided
between the Bodleian Library and the Ashmolean –
which included German, Dutch and Flemish draw-
ings, coins and medals, 27,000 prints, 13,000 printed
books and over 400 manuscripts. This was one of
the most valuable gifts ever received by the Univer-
sity. The importance of the Ashmolean as a centre
for studying prints and drawings is largely due to
Douce, while many of the finest ancient manuscripts
in the Bodleian came from him.

 Douce's collections of drawings is large and
contains many rarities but it was probably less
important in his eyes than his collection of prints
and manuscripts. His print collection is compre-
hensive and scholarly while his drawings seem to
have been chosen chiefly because they appealed to
his other interests. *The Dance of Death,* on which
he wrote an erudite and readable book, is a recur-
rent theme. Many of his drawings reveal his inter-
est in witches, skeletons, village festivities, games,
charlatans, fools, ornament and costume, illustrat-
ing the history of popular beliefs and customs
round which much of his museum developed. Cal-
lot's *Temptation of St Antony* must have seemed an
irresistible purchase because it represented a
favourite subject – he owned three Temptations of
St Antony by French artists – and also because it is
a spectacular drawing by a major printmaker.
Many of his French drawings, including a number
of neatly finished compositions by Bernard Picart

and Charles Eisen, are the work of printmakers.

Three years after the arrival of Douce's collection, the Bodleian received a gift of sixty-one elephant folio volumes of Clarendon's *History of the Rebellion* and Burnet's *History of his Own Times,* enlarged by the addition of over 19,000 interleaved prints and nearly 1,500 drawings. This collection, now in the Ashmolean, was begun by Alexander Hendras Sutherland, a Baltic merchant, who bequeathed it to his wife, Charlotte Hussey, in 1820. She continued to enlarge the collection and presented it to the University in 1837. The prints and drawings in the Sutherland volumes were added for the sake of illustrating seventeenth-century British history with topographical views, portraits and other subjects linked to the corresponding text in the two histories. The link between the image and the text is sometimes thin but the value for the Sutherlands lay above all in the imagery. They acquired many French drawings in the process – including some rarities – but no one would suggest that they were interested in French drawings as such, any more than Francis Douce; or, indeed any more than Chambers Hall, who presented a choice collections of prints and drawings by Claude Lorraine in 1855 along with many antiquities, Italian drawings, watercolours and etchings. Hall clearly liked landscapes – unlike Douce who had no interest in the subject – and was surely attracted to Claude as a landscapist. One suspects that the question of Claude's 'Frenchness' did not trouble him at all.

Before the late nineteenth century British collectors had only limited interest in the work of seventeenth- and eighteenth-century French painters. The great collections of French art in the Bowes Museum in Barnard Castle, in the Wallace Collection in London and in the Rothschild collection in Waddesdon Manor were formed by collectors who were as much at home in France as they were in Britain and their tastes were not typical. Watteau was one of the few French artists of the past who were widely admired in England. So too

were Claude, Poussin and Gaspard Dughet but their art was formed largely in Italy and it was certainly the Italian connexion which appealed to English taste.

Sir Karl Parker became interested in Watteau's drawings while working as a young assistant on the drawings in the British Museum. Following his arrival as Keeper of Fine Art in the Ashmolean in 1934, he began to acquire drawings by Watteau and his contemporaries but then extended his range to include drawings by a wide variety of French artists, from the sixteenth to the nineteenth centuries. Under Parker's care, the Ashmolean acquired many of its best French drawings. A glance at the dates when the drawings in this book were acquired indicates what the collection owes to him. When he arrived at the museum in 1934, he decided to build up a collection of nineteenth-century French drawings. In the first ten years of his keepership he acquired a number of very handsome drawings in this area, including a characteristically lively portrait by Ingres, a fine Degas, a good Tissot as well as works by lesser masters. However, Parker's interest in the French nineteenth century seems to have declined after the early 1940s and the present strength of the museum's collection of nineteenth-century French drawings is due almost entirely to substantial bequests from Florence Weldon (1937), Percy Moore Turner (1951), Dr Grete Ring (1954), John Bryson (1977), Richard and Sophie Walzer (1980) and others as well as large gifts and bequests of drawings from the Pissarro family.

Parker tended to buy in London, particularly from the firm of Colnaghi's where he bought a third of all the French drawings purchased by him for the museum. This tied him, to a large extent, to what was available on the London market. Most of the French drawings which Colnaghi stocked in this period were works by artists of the eighteenth century as were most of Parker's French acquisitions. Scholarship in this area was well founded by this date and only one of the many eighteenth-century French

drawings which Parker bought from Colnaghi's has since been reattributed. French seventeenth-century drawings, however, were less well known and there have been many changes of attributions in this part of the collection. When Parker was buying drawings, large areas of nineteenth-century French art were unfashionable and were, in the main, cheaper than other drawings. There was scope for pioneering acquisitions but owing to the general indifference to the work of the artists who exhibited at the 'Salon' their drawings did not appear on the market until the early 1970s when interest in their work revived. Parker made desultory stabs at buying in this area but the opportunities were few. After the publication of his catalogue of the Northern schools in 1938, his interests turned in the direction of Italy. The energy with which he acquired Italian drawings over the next few years has become a legend in the history of collecting but funds were tiny by comparison with the sums which have become available today and, faced by the choice of France or Italy, he sacrificed – to some extent – his early enthusiasm for the artists of the north.

If there are now few major French artists missing from the collection in the Ashmolean, this has been largely the result of luck, not to a policy of filling gaps. Until recently, the English have had little liking for the work of David and his followers and contemporaries and this is still a regrettably weak area in the collection. There are very large collections of the work of some artists – Jean Cotelle, Antoine Coypel, Claude Lorraine, Camille Pissarro and others – while there none by others – Lesueur, Boilly or Géricault, for example – whom one might expect to find in a history of French drawing. This booklet, however, is not intended to be a history of this kind but a survey of a collection in which the eccentricities and unexpected riches make up a great part of its charm.

1 **Jacques Callot** 1592–1635
The Temptation of St Antony
black chalk and brown wash
375 × 650 mm
inscribed: *Callot*
bequeathed by Francis Douce, 1834
1863.13

Callot would not have thought of himself as a French artist. He was born in Nancy, capital of Lorraine which was then a prosperous and independent duchy. At about the age of twenty, he went to Florence where many of his most famous prints were made. The pageantry and the festivities of the Medici court inspired several fanciful and grotesque prints but he also drew and etched subjects taken from street life. In 1621, he returned to Nancy and set up a successful and productive workshop. The period between 1633 when Lorraine was devastated by the French and his death in 1635 coincides with a darker tendency in his work. The famous series, *The Miseries and Misfortunes of War,* published in 1633, and his second print of *The Temptation of St Antony,* published in 1635, evoke the image of an earthly hell. To judge from the surviving drawings, Callot took particular care in preparing *The Temptation of St Antony.* There are five known studies of the entire composition – in Dresden, Oxford, Stockholm, St Petersburg and London, to list them in their likely order – which allow us to trace the development of the idea from the melancholy restraint which pervades the drawing in Oxford to the violent excess of the finished print. The empty space which spans the desolate setting in the Oxford drawing has become filled with monsters, grotesque warriors and a huge winged demon, hovering over the tiny figure of the tormented saint. The image is composed like a theatrical performance. The Oxford drawing shows us the set before the entry of the satanic chorus while the print represents the noisy climax. The drawing is broadly brushed over an outline in black chalk. The panache with which Callot handles the wash is characteristic of many of his preparatory drawings. He used a different style of drawing when making studies and when etching on the copper plate. His prints make extensive use of neat, swelling lines and careful hatching which would have been easy to approximate with pen and ink; but this was not Callot's manner and when one comes across a drawing which purports to be a preparatory study, hatched in the manner of the print, it is almost certainly a copy.

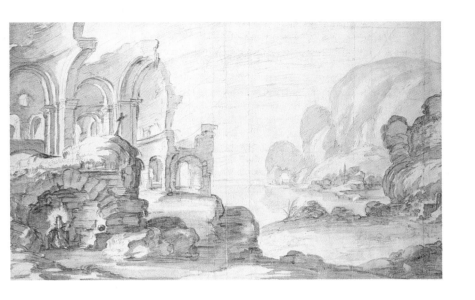

2 Jacques Stella 1596–1657

An oriental warrior and his retinue with an armed encampment in the background
black chalk with pen and brown ink and brown wash heightened with white bodycolour
291 x 419 mm
inscribed: *Jacq. Stella in/ 1631*
bequeathed by Francis Douce, 1834
1863.48

Jacques Stella's father was a Flemish painter who had emigrated to Lyons in the late sixteenth century. In 1616, the younger Stella moved to Florence where he remained for twelve years. This drawing is dated 1631 when he was in Rome but the type of composition recalls the work of earlier Florentine artists, Tempesta in particular. The complex, decorative detail, elaborately finished with pen and wash and heightened with streaks of white bodycolour, can also be matched without difficulty in the work of his Florentine predecessors. The subject was believed at one time to represent an episode from Ariosto's epic poem of chivalry, *Orlando Furioso*, on the grounds that the boy and the older man on the left might represent the young Ippolito d'Este with the Hungarian warrior, Matthias Corvin, by his side. The coats of arms, however, do not match and it has been recently pointed out that this is almost certainly a composition which was designed to be engraved and published to accompany a thesis, submitted by a student at the Collegio Clementino in Rome. The band inscribed across the sky is a device of Pope Clement VIII who founded the college. The dog and crowned eagle which are found in the arms of the Scaglia family, combined here with a cardinal's hat, point in the direction of cardinal Desiderio Scaglia. The boy seems to be carrying a shield with the arms of the Brusati family from Legnano. The convention for prints of this type indicates that the young Brusati, standing on the left, has submitted a thesis under the sponsorship of Desiderio Scaglia at the Collegio Clementino. So far, neither the thesis nor the print has come to light but as the Scaglia dog is facing the wrong way and all the soldiers carry swords on the right, it seems certain that the drawing was made for a print. Like many artists before and since, Stella prepared his drawing in the knowledge that printmaking always produces a mirror-image of the original design. It has also been folded twice, as are many drawings prepared for printing, presumably because it was the habit to fold drawings when they were sent to and from the printmaker.

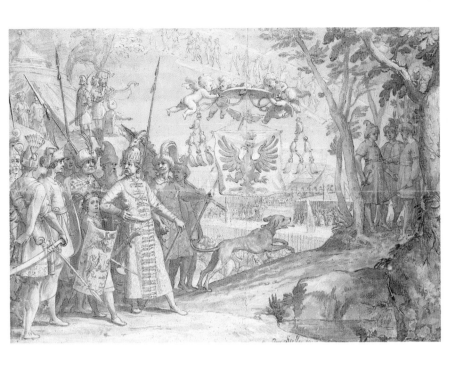

3 **Guy François** before 1580–1650
 The Entombment of Christ
 charcoal, heightened with white chalk over pale
 brown wash
 400 × 286 mm (arched top)
 purchased with contributions from the National
 Art Collections Fund, the Museums and Galleries
 Commission/V. & A. Purchase Grant Fund and
 the Friends of the Ashmolean, 1997
 1997.52

Caravaggio's down-to-earth treatment of religious sub-
jects had a more lasting impact in North Europe than it
had in his native Italy. His light effects and his rejection
of ideal beauty caught the imagination of painters from
Flanders and France who came to Rome in the early sev-
enteenth century as well as others, like Georges de la
Tour who does not seem to have gone to Italy and prob-
ably never saw his work at first hand. Guy François,
who is recorded in Rome in 1608, certainly knew the
work of Caravaggio and was lastingly affected both by it
and by the art of other painters in his circle. Drawings
by French followers of Caravaggio are notoriously diffi-
cult to identify and it is only recently that this drawing
has been convincingly linked to a study of the Madonna
in the Ecole des Beaux-Arts in Paris which can be attrib-
uted to him by comparing it to a number of his paint-
ings. This is thin thread with which to link this drawing
to Guy François but it is strong enough. The drawing in
Paris is very close in character to the Madonna in his
paintings and, like the drawing in Oxford, it is drawn
with a distinctive use of thick, greasy charcoal, height-
ened with white, applied to a toned ground. The compo-
sition of the Oxford drawing is based closely on
Caravaggio's *Entombment* (now in the Vatican Museum)
but altered to make the composition less diagonal and
more conventionally pyramidal. François was back in
his native Le Puy by 1613 and may have drawn this as a
model for one of the many commissions he received to
supply altarpieces to the local churches. It has been sug-
gested that the artist might have followed tradition in
giving Nicodemus (the elderly figure supporting Christ
on the right) his own features. This may be correct but is
difficult to prove. If this is a self-portrait he is not young
and the drawing must date from late in his career.

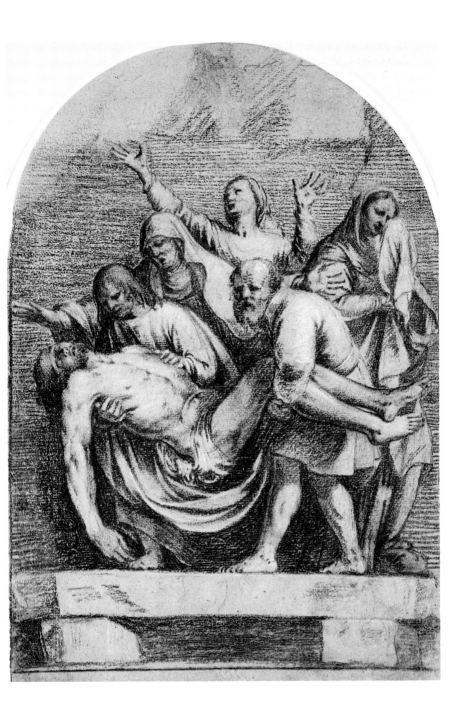

4 Claude Lorraine *c.*1604–1682
The Tomb of Cecilia Metella
black chalk with pen and brown ink and grey
brown wash
177 × 252 mm
inscribed: *Capo da bove 1669/ Claudio fecit*
presented by Chambers Hall, 1855
1855.55

At an early age, Claude left his native Lorraine and set-
tled in Rome. Apart from a brief stay in Lorraine
between 1625 and 1627, he spent the rest of his life in
Italy. The mannerism of his early paintings, chiefly influ-
enced by his master, Agostino Tassi, gave way in the
early 1630s to a fresher naturalism, shared by the North-
ern painters with whom he associated. In the company
of the Northerners, Claude learned the value of drawing
in the open air. His drawings done out of doors, using a
combination of pen, wash and chalk, are bold, luminous,
atmospheric and informal. In the 1640s, he adopted a
dryer and more controlled pen line which is less sponta-
neous in appearance and was probably the result of an
increasing interest in the drawings of Grimaldi and the
Bolognese. Many of these later pen drawings of land-
scape were probably drawn in the studio. Given time
and good weather, there is no reason why Claude
should not have drawn this view, at least in part, from a
seat on the Appian Way, looking south towards the
ancient tomb of Cecilia Metella. But by 1669, the date
which appears in the inscription, Claude was in his mid-
sixties and ailing and his walking tours must have
become less frequent. He may have drawn the outline of
this view in the open air but it is likely that the careful
work in ink was added later in the studio. Views of this
type, recording famous sites in and around Rome, are
common in the work of contemporary printmakers. The
inscription on the drawing *Capo da bove* – 'Ox head' –
refers to the name by which the monument was com-
monly known on account of the series of ox skulls run-
ning in a frieze round the upper rim.

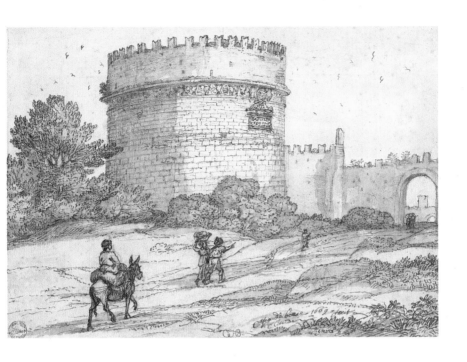

5 **Nicolas Poussin** 1594–1665
 A view across a valley towards distant hills
 brush and reddish-brown wash over faint black
 chalk
 132 × 257 mm
 purchased with contributions from the National
 Heritage Memorial Fund, the National Art Col-
 lections Fund, the Museums and Galleries Com-
 mission/V. & A. Purchase Grant Fund and the
 Friends of the Ashmolean, 1992
 1992.10

Drawings by Poussin for figure compositions are often
executed in a spare, somewhat charmless style with a
spidery pen line and pale wash and are not difficult to
attribute. His landscape drawings, on the other hand,
have divided scholars. The tendency nowadays is to
restrict the attribution of landscape drawings to Poussin
to a minimum. This is one of the few landscape draw-
ings attributed to Poussin about which there is much
agreement. The dry, firm handling of the wash, applied
with the tip of the brush, can be found in other drawings
attributed to Poussin, including one or two which relate
to paintings. No paintings relate directly to this drawing
but Poussin used a similar horizontal counterpoint of
lines and tones in the background of a number of pic-
tures of the 1640s which must have been based on stud-
ies like this. It appears to have been drawn on the page
of a sketchbook from a site above a valley looking
towards a range of hills which rise above a distant band
of haze. The countryside is typical of the Tiber valley
where Poussin and his friends made frequent sketching
excursions.

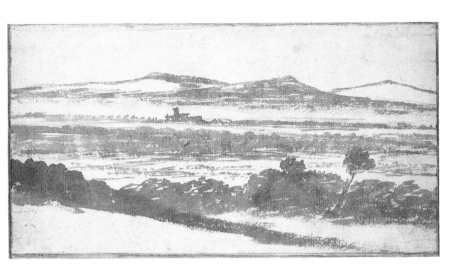

6 **Gaspard Dughet,** called **Gaspard Poussin**
1615–1675
Two Trees in a Rocky Landscape
black chalk with brush and brown ink on pale
beige paper
390 × 268 mm
purchased, 1940
1940.67

Dughet's family came from France but he was born in
Rome and spent his life in Italy, working alongside Ital-
ian and Northern landscape painters. His frescoes of
scenes from the lives of Elijah and Elisha in the church
of S. Martino ai Monti in Rome made his reputation as a
painter of murals but he also specialised in easel paint-
ings. This study of entwined trees was at one time attrib-
uted to Dughet's brother-in-law, Nicolas Poussin, but it
has since been noticed that it corresponds closely to a
detail on the left side of Dughet's fresco in S. Martino ai
Monti, *The Punishment of the Priests of Baal.* The fres-
coes are believed to have been painted in 1648–49 from
which it follows that the drawing in Oxford was proba-
bly drawn in *c.*1648. Most of Dughet's pen and wash
drawings seem to date from before 1650 but there is dis-
agreement among scholars about which of the many
drawings of this kind attributed to Dughet are really by
him. This link with the fresco is proof enough that this
drawing is his but even without this evidence, the simi-
larities between the drawing and Dughet's more famil-
iar and less controversial landscape drawings in black
chalk point in his direction. Dughet's habit of filling dark
areas in his chalk drawings with patches of abrupt
hatching in black chalk recalls the use of washes in this
drawing which are scattered in a decorative pattern
across the surface of the paper. The spiky treatment of
the leaves added with the tip of the brush also corre-
sponds to the way he draws foliage in black chalk.

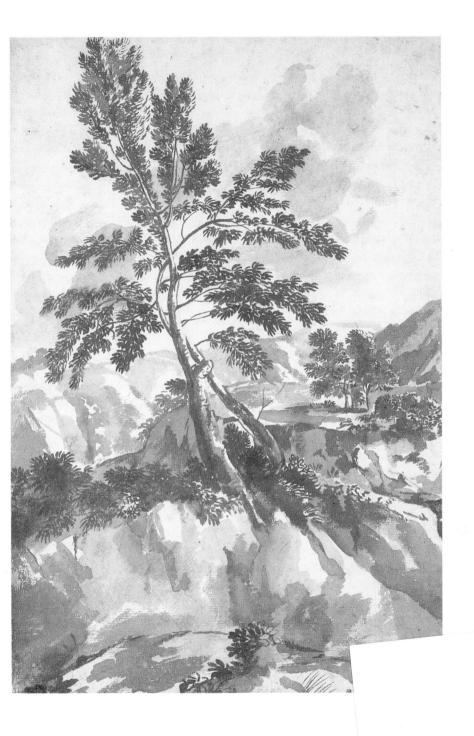

7 Laurent de la Hyre 1606–1656
Cornelia, mother of the Gracchi, refusing an offer
of marriage from Ptolemy of Egypt
black chalk with grey wash
450 × 331 mm
purchased, 1964
1964.52.1

La Hyre never visited Italy but he absorbed the lessons of Italian art at second hand. His mannered treatment of the human figure owes something to the painters who worked at the palace of Fontainebleau in La Hyre's youth but it is combined here with a rigour and a frozen clarity of form which were fashionable in French art in the 1640s. The composition illustrates a story, told by the Roman historian Plutarch, which describes how Cornelia, widow of the the consul Tiberius Gracchus, refused an offer of marriage from the King of Egypt because she preferred to remain in Rome to educate her children. The simple interplay of gestures and the clarity of the drawing style are in keeping with the moral spirit of the story. The drawing was made for a painting, dated 1646, now in the museum of Budapest, which is composed within a less tall format. It has been suggested that the painting has been cut down. The importance of the large column on the left side of the drawing which points downwards to the significant gesture of Cornelia's right arm is certainly less effective in the painting than it is here.

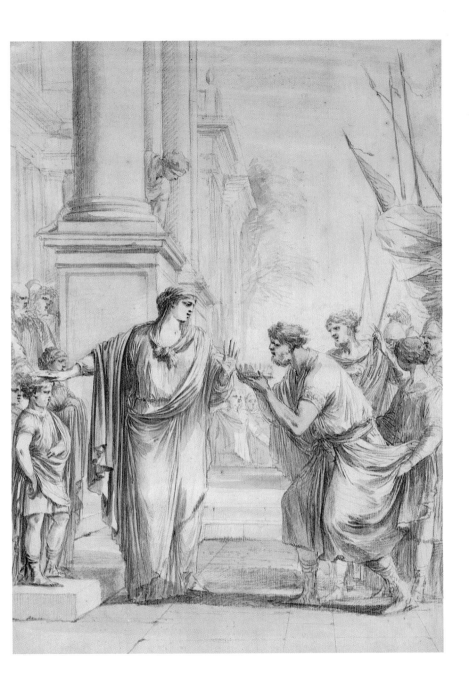

8 **Charles Lebrun** 1619–1690
The penitent Magdalen
red chalk, heightened with white chalk, on buff
paper
331 × 268 mm
inscribed lower left: *Le Brun*
purchased, 1956
1956.57

Charles Lebrun was the foremost of a talented genera-
tion of French artists who studied with Simon Vouet in
the 1630s and 40s and developed Vouet's Italianate
approach to painting through a structured process of
preparatory drawing. Compositions were laid out in an
initial sketch; models were posed to correspond with
the sketch and studied in the nude; draperies were dealt
with at a separate stage and the different elements were
then combined in a finished composition. This drawing
belongs to the stage at which the artist has turned his
attention to the drapery. The face – always highly impor-
tant in Lebrun's finished paintings – was not of impor-
tance in this study and is only lightly indicated. The
work to which it corresponds, now in the Louvre, was
painted for a chapel in the Carmelite Church in the rue
St Jacques in Paris. The chapel, built in memory of the
cardinal de Bérulle, was decorated with images of the
Magdalen for whom the cardinal had a special venera-
tion. Lebrun's painting faced the statue of the kneeling
cardinal, carved by Sarrazin in 1656–7. The painting was
presumably commissioned at the same time as the stat-
ue. The abundant cloak which she pulls off with her
right hand and the jewel casket overturned at her feet,
express her rejection of wordly goods.

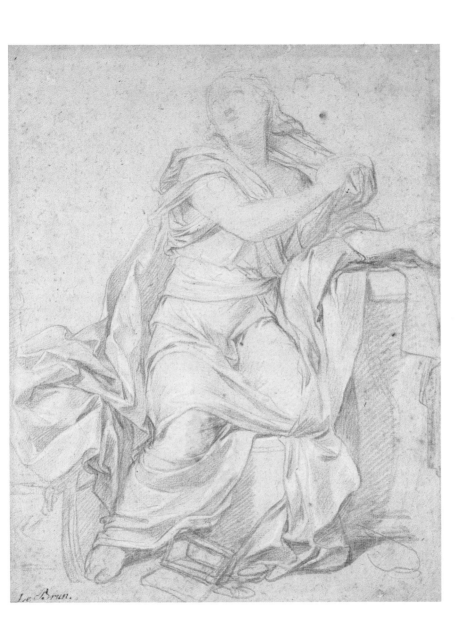

Le Brun.

23

9 **Nicolas Mignard** 1606–1668
An angel seated on a cloud, playing a lute
red chalk, heightened with white chalk and
touched with black chalk on the hand study, on
beige paper
415 × 264 mm
purchased, 1942
1942.87

This drawing was for long attributed to the Italian artist,
Giuseppe Chiari, until it was pointed out that it is a char-
acteristic drawing by Nicolas Mignard which relates to
the figure of an angel in the upper part of a painting of
the Nativity in a church in Aix-en-Provence, signed and
dated 1657. Like Lebrun, Nicolas Mignard and his broth-
er Pierre were trained by Simon Vouet but their art is
less severe than Lebrun's. They responded to the charm
of the art of Domenichino and Albano but did not share
Lebrun's enthusiasm for the more cerebral work of
Poussin. Pierre, in particular, became Lebrun's chief
rival, succeeding him as Director of the Academy in
Paris and first painter to the king in 1690. This soft, ele-
gant drawing has none of the classical rigour which was
fashionable in Paris during the ascendancy of Lebrun,
and has more in common with the lighter taste of
Lemoyne and the artists of the next century.

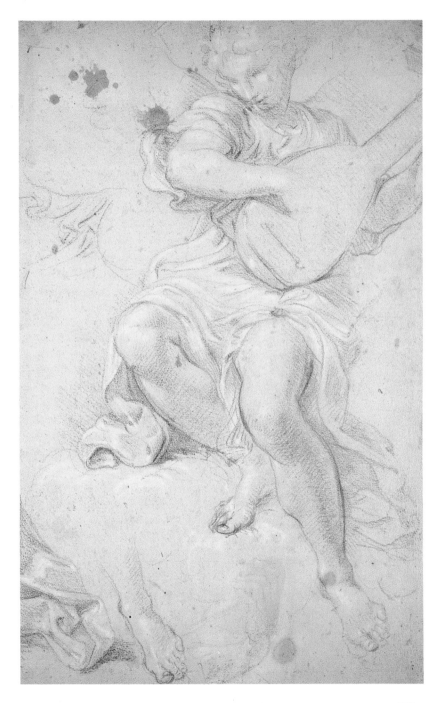

25

10 Jean-Baptiste Corneille 1649–1695
The destruction of heresy
pen and brown ink and brown wash over black
chalk with slight touches of bodycolour and paint
stains; two patches of irregularly cut pale beige
paper with altered detail, pasted down
433 × 281 mm
inscribed with explanatory texts
purchased, 1945
1945.118

This is a typical drawing by Jean-Baptiste Corneille who
was a more lively and idiosyncratic draughtsman than
his brother Michel to whom it was formerly attributed.
It has been identified as a study for a large painting,
commissioned by the Paris Jesuits, to accompany the
ceremony marking the beginning of the term at the Col-
lège Louis-le-Grand on 17 December 1686. The orator
presiding at the ceremony praised the wisdom of Louis
XIV in revoking the Edict of Nantes which had previous-
ly ensured the rights of Protestants in France. This is the
theme of the drawing which shows an oval portrait of
the king, supported by Piety and Wisdom and crowned
by Felicity while the dead Hydra below represents the
overthrow of Heresy. This drawing was probably made
as a model for the approval of the Jesuits. The patches
suggest some corrections and the inscriptions below the
figures, copied not very accurately by the artist from
earlier inscriptions by another hand, were subsequently
revised by the author of the original inscriptions. The
original texts and the later corrections were probably
written by Gabriel Le Jay, the Jesuit scholar who invent-
ed the symbolism and who published an explanatory
booklet of the event in 1687.

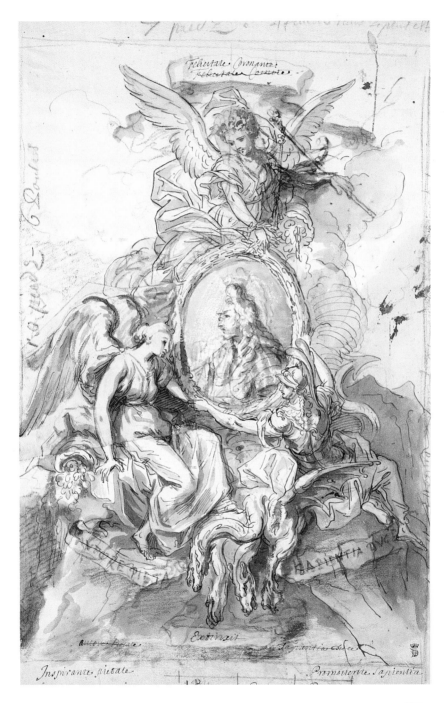

11 Antoine Coypel 1661–1722
A Seated Faun
black, red and white chalks on buff paper
364 × 271 mm
purchased, 1955
1955.45

Antoine Coypel was twelve years old when his father,
Noël Coypel, was appointed to direct the French Acade-
my in Rome. During this period in Italy, the young
Coypel perfected his drawing skill and acquired his taste
for Annibale Carracci, Correggio and the Venetian
artists of the sixteenth century. Later, in Paris, he added
Rubens to the list. His sympathy for these artists was
evident in the expansive effects which he used when
painting the ceiling of the main Salon in the Palais Royal
(now destroyed) and the vault of the chapel in the palace
of Versailles. This study of a seated faun must have been
drawn for a figure, seated on a scroll in the cove of a
ceiling, paired with a second faun, facing the opposite
way and supporting the other end of the swag of foliage.
Coypel would have seen similar figures in Annibale Car-
racci's ceiling in the Farnese Gallery and, nearer home,
in Houasse's ceiling in the Salon de Venus in Versailles.
There is a companion study of a faun in the National
Gallery of Canada and three others have appeared in
London sales. These came from an album of drawings
sold in the 1950s with an attribution to Coypel's contem-
porary, Louis de Boullogne. Boullogne's manner of
drawing, however, is softer than this. The use of red and
black chalks with white chalk highlights, is found in the
drawings of several early eighteenth-century French
artists, including Watteau, who would have been famil-
iar with this manner of drawing in the work of Rubens,
but the firm, vigorous modelling, based on a figure stud-
ied in the lifeclass, is typical of Coypel's drawings from
the life model.

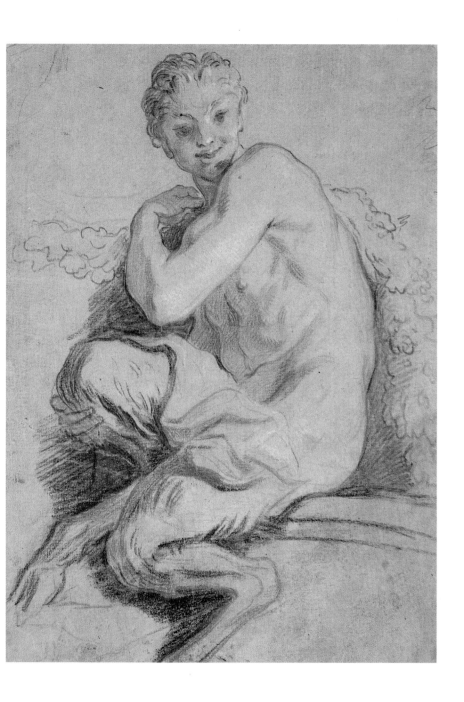

12 Antoine Watteau 1684–1721
*Two studies of the doctor in the Italian Comedy
and four of officers*
red chalk
235 × 169 mm
bequeathed by Francis Douce, 1834
1863.126

Throughout his brief working life, Watteau made abundant drawings in red chalk. Until *c.*1712 he used nothing else but then began to add black chalk for shadows and accessories and white chalk for the highlights. At first he drew with a light, sharp point but gradually adopted a darker, more greasy and painterly touch. Most contemporary artists, including his friend and master, Claude Gillot, used a wider range of drawing instruments than this but few in any medium equalled Watteau's magical effects. From an early age he filled his sketchbooks with studies of heads, hands, costumes, figures of all kinds and copies of details from paintings by the Old Masters. Sometimes, when the subject required it, he posed figures for a composition but more commonly turned to his stock of drawings from which he selected suitable figures. This was not the traditional method of preparing paintings and it seems to have encouraged him to think increasingly of the sheet of studies as an independent work of art. When preparing prints, Watteau's method was more complex. Three of the figures on this sheet reappear in three separate prints. One might assume that the drawing was made first from life and the prints followed but the existence of several of the figures in other drawings makes this uncertain. Watteau took the figures in his paintings directly from his studies with little or no work in between but made copies and model drawings when preparing prints. Perhaps this drawing came first, the models were copied from it and the prints would have followed. The prints have been dated between *c.*1710 and *c.*1713 and the drawing between *c.*1709 and *c.*1712. The figure in the large hat is the Doctor from the Italian Comedy – the *Commedia dell'Arte* – whose stock characters often reappear in Watteau's poetic universe.

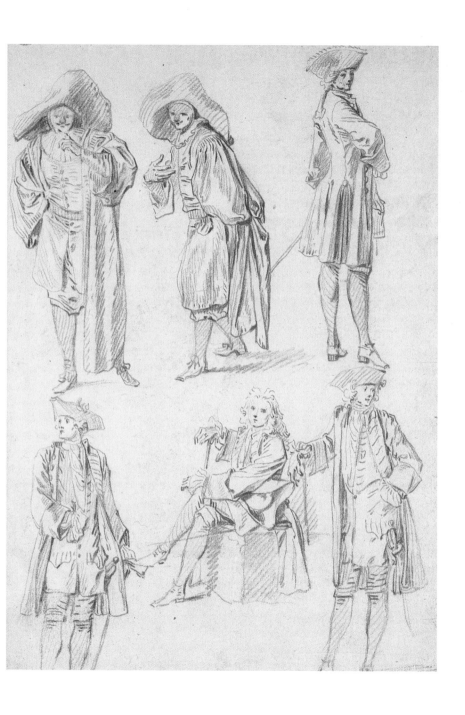

13 Antoine Watteau 1684–1721

A girl seated with a book of music on her lap
red, black and white chalks on coarse-textured
brown paper
245 × 156 mm
presented by Emma Joseph, 1942
1942.46

From the Renaissance to the twentieth century, the
practice of figure drawing was inseparable from the art
of painting. It was the basis of Watteau's art, also, but he
used it in a manner which was not conventional. He did
not make a distinction between the nude figure and the
drapery and in a drawing like this, he shows little aware-
ness of the figure beneath the clothes. He drew her as
she must have appeared to him, using the warm flesh
colour of red chalk for the face and hands and adding
her dress in black chalk, touched with shimmering
effects of white. It is not clear what she is sitting on and
the lower edge of her dress seems somewhat ill-defined.
Perhaps Watteau could not see this detail clearly from
his vantage point. It is notable that in both paintings in
which this figure appears, *The Concert* in Potsdam and
the related painting in the Wallace Collection, he took
care to conceal or cut off the lower edge of the dress. In
both paintings, however, he gave her a circle of plaits in
place of the high knot of hair which perhaps too abrupt-
ly continues the line of her neck in the drawing. She is
not singing but sits fingering her book of music,
absorbed in thought. This idea is taken up in the paint-
ings which represent a silent moment before the music
has begun and it may be that when Watteau drew this
model, he was already thinking of the picture. The paint-
ing in Potsdam, which seems to be earlier than the
painting in the Wallace collection, has been dated
*c.*1716. If this is a study for the painting, the drawing and
the painting must be close in date.

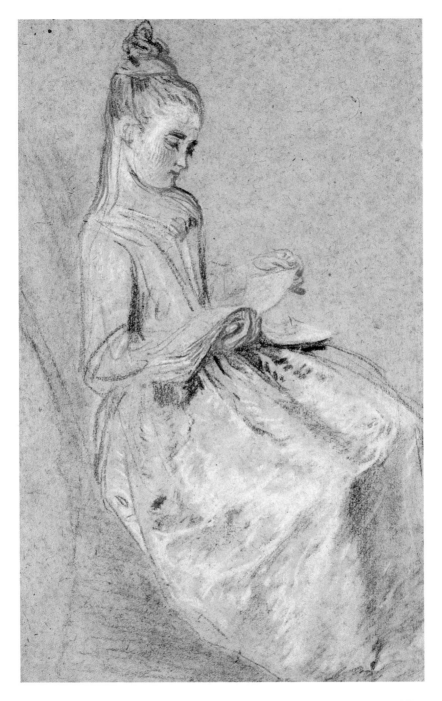

14 **Bernard Picart** 1673–1733
A Water-finder
pen and black ink with grey wash inscribed
along the outlines with a stylus
314 × 218 mm
inscribed: *Picart f: 1726*
bequeathed by Francis Douce, 1834
1863.44

Most of Picart's drawings are linked to his work as a
print-maker. His neat, accurate work in pen and ink or
red chalk translated easily into line engraving. In 1711
he settled in Amsterdam where he became a successful
book illustrator and teacher. Judging from the number
of his life drawings which are known today, he must also
have spent much time in the life-class. This composition
was drawn to illustrate the first English translation of
Alberti's book of architecture, published in London in
1726. The book may have been published initially with-
out the plates – or publication may have been delayed –
as the print which corresponds to this drawing indicates
that it was drawn in 1727. It illustrates a passage in
Alberti's text which describes a method for detecting
underground water: 'In the morning extremely early,
when the air is perfectly clear and serene, lay yourself
flat with your chin resting on the ground; then take a
careful survey of the Country all round you, and wher-
ever you see a vapour rising out of the earth and curling
up into the air like a man's breath in a clear frost, here
you may be pretty certain of finding water'. The plants
in the background of the drawing are also mentioned in
the text. The print exists in a version with a French
inscription but no corresponding French edition is
known.

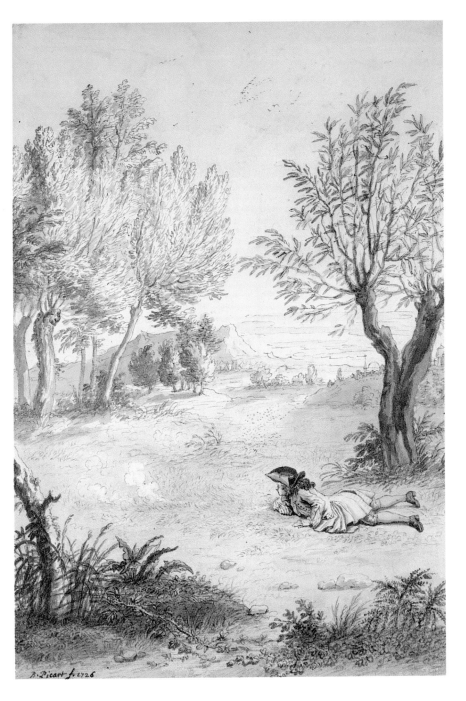

B. Picart f. 1726

15 François Boucher 1703–1770
The invention of drawing
brown chalk
159 × 212 mm
presented by Langton Douglas, 1938
1938.42

Boucher was a prolific draughtsman. Like other artists trained in the academic tradition, he prepared his paintings with figure studies drawn from life. He also supplied drawings for prints, book illustrations, tapestries, porcelain and metalwork and made many others for sale to collectors as independent works of art. He drew from the model and from his imagination with equal facility, covering a wide range of subjects and using many different media. This composition illustrates a story told by the Roman author, Pliny the Elder, describing how the art of drawing was discovered by a Corinthian girl, who traced the shadow of her lover on the wall. This pleasant tale linking the origin of their profession with the power of love appealed to eighteenth-century artists. The use of brown chalk is less common in drawing than red or black chalk and its use by Boucher seems to date largely from the 1760s when he used it for drawing compositions. It has been suggested that these drawings were made specifically as models for prints in the crayon manner, a technique which enabled printmakers to imitate the effect of chalk. No print corresponding to this drawing is known but as the artist is drawing with her left hand, Boucher may have composed it in reverse to enable it to be transferred directly onto the printing plate.

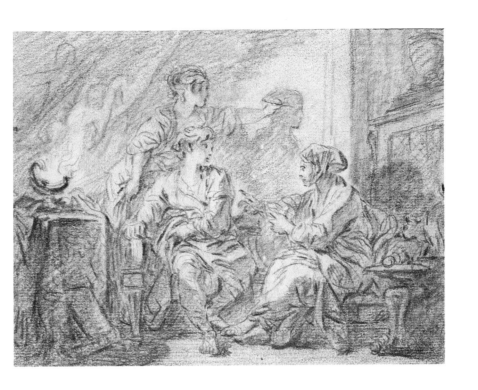

16 **Jean-Baptiste Oudry** 1686–1755
*A heap of fish with a bird, pierced by an arrow, in
the foreground*
black and white chalks on greenish-grey paper
264 × 336 mm
inscribed: *J.B.Oudry*
purchased, 1938
1938.100

Oudry's many pictures of dogs, wild animals and still-
life of game appealed to court society and to people of
wealth for whom hunting was a favourite recreation.
Both Oudry and his older rival, François Desportes,
designed costly tapestries for the same clientèle. In 1726,
Oudry was appointed to the post of chief designer to the
Beauvais tapestry works and in 1736 he took up the
same post at the Gobelins in Paris. This drawing is a
study for *The Fish of Glaucus*, the seventh of a set of
eight designs illustrating themes from Ovid's *Metamor-
phoses*, commissioned by the tapestry works at Beau-
vais from Oudry in 1732. The tapestry corresponding to
the drawing is lost but the summary description in the
factory register, which mentions an eagle, shells, dogs,
trees, rocks, nets and architecture, suggests that this
drawing is not the final idea. Of the four known draw-
ings for this tapestry, none includes any architecture
which was probably introduced at a late stage for the
sake of unifying the set. The story of Glaucus is based on
an episode from Book XIII of Ovid's text which tells how
the fisherman Glaucus was transformed into a marine
divinity by eating magic herbs. His attention had been
drawn to the herbs when he saw how they had the
power to restore life to the fish which he had cast onto
the bank. His fish occupy the foreground while Glaucus
is visible on the right. The eagle seems to have been
taken from a different tale in Book XII which tells how
Periclymenus, transformed into an eagle, was shot by
Hercules.

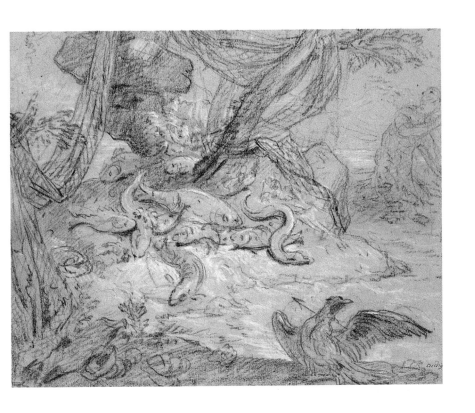

17 Jean-Baptiste Massé 1687–1767
Portrait of Pierre-Jean Mariette
black chalk, stumped, with red and white chalks
188 × 146 mm
bequeathed by Francis Douce, 1834
1863.118

The miniature painter, Jean-Baptiste Massé, bequeathed his collection of portrait studies to his nephew on the express understanding that they were not to be sold. Presumably Massé himself must have given some away since several, including this study which belonged to the sitter, were already in private collections in the eighteenth century. Many others, however, remained together and were not dispersed until the late 1980s. These were not finished portraits but studies for miniatures, retained, as a rule, as a record by the artist. According to his fellow artist, Charles-Nicolas Cochin, 'Massé took few sittings and often made his portraits almost entirely with no other model than a drawing made fairly rapidly from life'. The use of the stump, a blunt instrument for making smudged effects, is found in many of these studies. The subject of this drawing, Pierre-Jean Mariette, was one of the most important figures in the world of eighteenth-century connoisseurship. He inherited a thriving print-publishing business as well as a collection of prints and drawings on which he based much of his work as a historian of art. By the time of his death, he owned a vast collection of prints as well as over 9,000 drawings, mostly by Italian artists but including groups by several of his French contemporaries. An inscription by Mariette on the mount of this portrait testifies to the friendship between the artist and the sitter. It also informs us that it was drawn in 1735 when Mariette would have been forty or forty-one. Mariette's notes, published in the 1850s, confirm the warmth of his friendship for the artist but reveal less enthusiasm for his art: 'everything he has done is cold and without verve'.

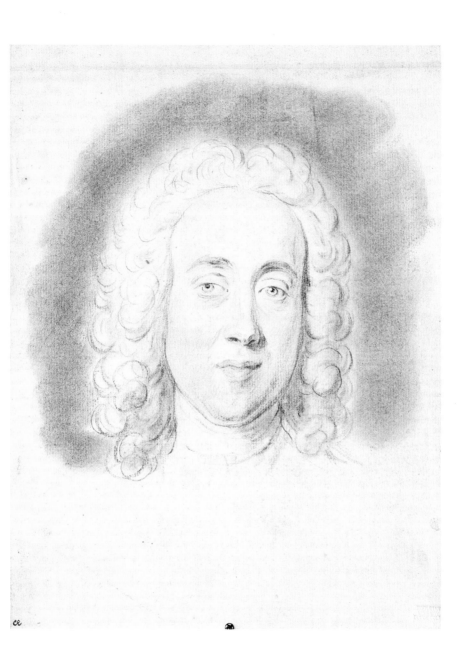

18 **Etienne Parrocel** 1696–1775
Four oriental soldiers
black and white chalks on faded blue paper
420 × 540 mm
inscribed: *2B*
purchased, 1998
1998.82

Etienne Parrocel belonged to a numerous family of painters from Provence. In 1717, he accompanied an uncle to Rome where he remained for the rest of his life, specialising in altarpieces which he painted for many churches in France, in the papal states and in Rome. He drew rapidly with a light black chalk, revising and refining the details of his compositions in successive variants. This group has not yet been identified among his many paintings but the postures and gestures suggest a group of soldiers falling over in amazement at the spectacle of Christ's resurrection. The letter B, inscribed on this drawing and on others by the artist, represent values expressed in *baïoque*, a currency in common use in the papal states.

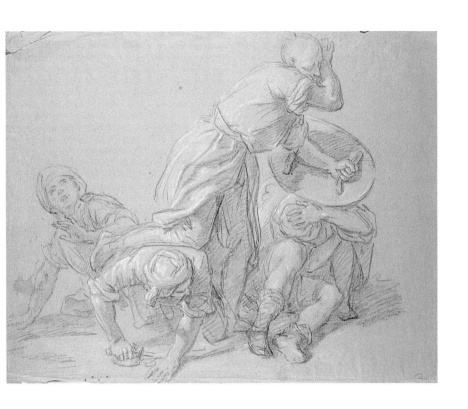

19 **Jean-Baptiste Marie Pierre** 1713–1789
The Deposition
red chalk
366 × 243 mm
inscribed: *Pierre*
purchased, 1935
1935.145

A pupil of Natoire, Pierre won the Rome Prize in 1734.
The first pictures which he exhibited in Paris were
scenes of contemporary life but he quickly turned from
these towards more elevated historical and religious
compositions, reversing a common tendency among
French painters to abandon history and specialise in
smaller, less demanding and more commercial pictures
of daily life. His serious compositions brought important
official appointments which left him with little time for
painting in his later years. This is one of three known
studies in red chalk for Pierre's *Deposition* in Versailles
cathedral, which was exhibited in Paris in 1761. The
striking differences between each of the studies indi-
cates some indecision in Pierre's mind. The composition
became more earth-bound as it developed, suggesting
that the drawing in Oxford should be placed in the mid-
dle of the three studies. When the painting was exhibit-
ed, Diderot noticed that the artist had probably been
helped in his difficulties by Annibale Carracci's *Deposi-
tion*, now in the National Gallery in London, but hardly
to the point of plagiarism as Diderot claimed. Great
altarpieces of religious subjects are not commonly asso-
ciated with the age of Louis XV but they are by no means
uncommon and sometimes of the finest quality.

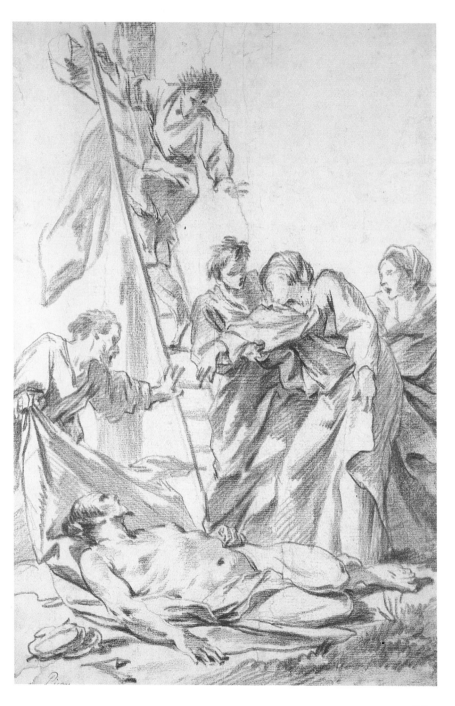

20 **Anonymous** mid-18th century
A seated figure, dressed for a Turkish masquerade
red chalk
481 × 358 mm
inscribed: *J. Vien*
purchased with a contribution from the National
Art Collections Fund in memory of Denys
Munby, 1976
1976.75

The authorship of the group of figure studies to which
this sheet belongs is one of the puzzles of eighteenth-
century drawing. The date and occasion on which they
were drawn are known. So are the names of several
artists who were in the room with the draughtsman at
the time. The bold, broad, heavy touch with which the
artist has drawn the costume, exaggerating the vol-
umes, is highly distinctive and three other drawings by
him are known (in counterproofs) but he has not yet
been identified. The drawings were made during the
Roman carnival of 1748 when the French students at the
Academy organised a Turkish masquerade. Each of the
students in the masquerade drew the other students,
presumably in place of the life class which was suspend-
ed during the Easter period. Remains of four other sets
have been identified. A set of twenty-two drawings
made on this occasion by Joseph-Marie Vien survives in
the Petit Palais in Paris; another twenty-one, now dis-
persed, were drawn by an artist whose identity is uncer-
tain; three by Jean Barbault and one unattributed. Two
other drawings of this seated figure appear in two of the
other sets, one by Vien, the other now in the Metropoli-
tan Museum in New York from the set of twenty-one;
both show the figure from slightly different angles. Vien
must have been seated between our artist and the
author of the drawing in New York. An inscription on
the drawing in New York identifies the sitter as 'M.Clé-
ment'. No M.Clément is listed among the students at the
Academy in Rome in 1748 but he was presumably a
member of the French colony in the city who frequented
the Academy, possibly the M.Clément who competed
unsuccessfully for the Rome Prize in 1744 and might
have reached Rome by other means.

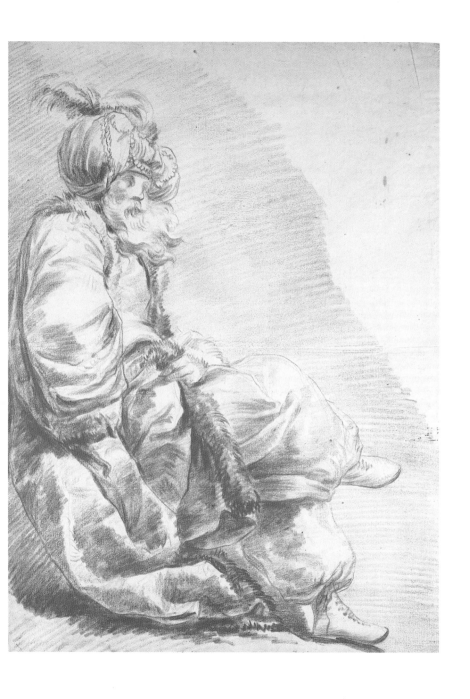

21 Charles-Nicolas Cochin 1715–1790
The entrance to a garden
black chalk and bodycolour
230 × 154 mm
inscribed: *Cochin filius 1746*; and on the mount:
Vue de L'Entrée du Jardin de la Tirelire
presented by F. A. Drey through the National Art
Collections Fund, 1938
1938.46

Cochin designed and engraved many vignettes, fron-
tispieces, book illustrations and other prints and played
an important role in the official art world as secretary to
the French Academy in Paris. He encouraged a prag-
matic approach to the education of the artist, warning
against the ill-effects of too much theory and criticising
contemporary art schools for concentrating excessively
on drawing at the expense of painting. Above all, he rec-
ommended that artists should work from nature and
should use colour in place of the monochrome tech-
niques commonly used by artists when studying land-
scape and when working in the studio from the model.
This watercolour may seem an ideal illustration of his
ideas but it is quite untypical of his art. Landscapes by
Cochin are very rare and colour is almost entirely
absent. Among his many known drawings, this informal
view is unique as a watercolour which seems to have
been drawn in the open air. The garden must be French
as Cochin spent 1746 in Paris but it has not been identi-
fied.

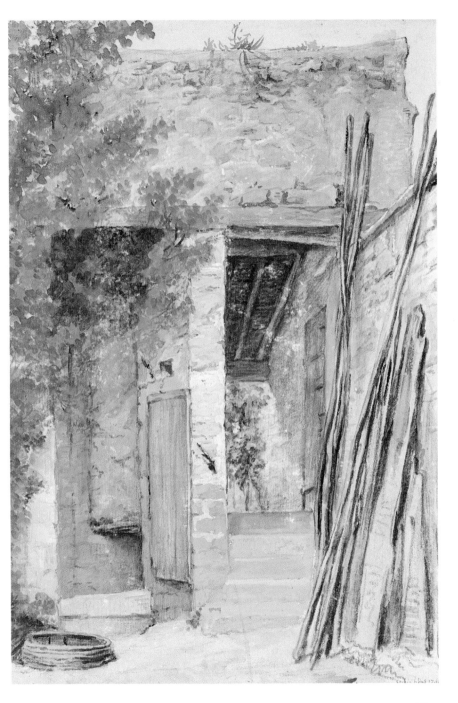

22 **Charles Joseph Natoire** 1700–1777
*A View from the gardens of the Villa Farnese in
Rome*
black and red chalks with pen and brown ink,
brown wash and bodycolours on grey paper
301 × 470 mm
inscribed: *villa Farnese*; and: *C. NATOIRE. 15
Octob./1764*
purchased, 1936
1936.169

Natoire, like Boucher, acquired his talent for painting
decorative works of allegory and mythology while
studying with François Lemoyne. His distinctive and
pleasing manner brought him many private and official
commissions. In 1751 he was appointed to direct the
French Academy in Rome. He did not return to France
and seems to have painted little in his later years. During
the period of his directorship – which lasted until 1775 –
he encouraged the students to take advantage of the
Roman countryside to study landscape, as Claude had
done a century before, and he spent much of his own
free time making drawings of the picturesque sites in
and around the city. Several of these landscapes, includ-
ing this view taken from the hill on the side of the
Forum, represent sites in the gardens of the Villa Far-
nese on the Palatine close to the garden which he
bought in 1755 near the present via dei Cerchi. These
drawings appear to have been drawn in outline out of
doors and elaborated in the studio where the artist
added the figures and other accessories and completed
the work in watercolour and gouache. The chalk lines of
the view are often plainly visible through the added fig-
ures which are sometimes drawn out of scale with their
surroundings. The horseman in this view is a stock type
in Natoire's drawings, based on Bernini's statue of Con-
stantine in the porch of St Peter's.

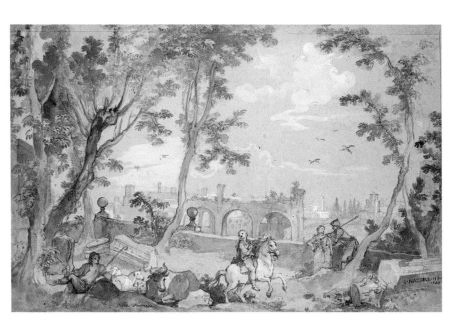

23 **Hubert Robert** 1733–1808
A view of the gardens of the Villa Conti at Frascati
reddish-brown chalk
442 × 336 mm
inscribed: *à villa conti à frascati 1764 HR*
purchased, 1934
1934.282

During the years he spent in Italy from 1753 to 1765, Robert made a huge quantity of drawings of buildings and antiquities. His manner of drawing in red chalk using fine contours and bold, broad hatching is sometimes deceptively similar to Fragonard's but often lacks the animation which Fragonard infused into his contours and shadows. Robert, however, endowed his subjects with a poetic and sometimes melancholy wit. Dilapidation and the cult of the picturesque garden appealed to his sense of the elegiac. The date and the monogram on this drawing are not in the artist's handwriting but were probably added by someone who was familiar with his views of Roman gardens, dating from 1763–4, several of which are drawn on similar large sheets of the same format. From a number of dated views of gardens in the Frascati region, it appears that Robert was working in and around the garden of the Villa Conti in 1761–2. The pale statue, perched on a dilapidated wall, makes a romantic contrast with the dark shadow of the trees behind.

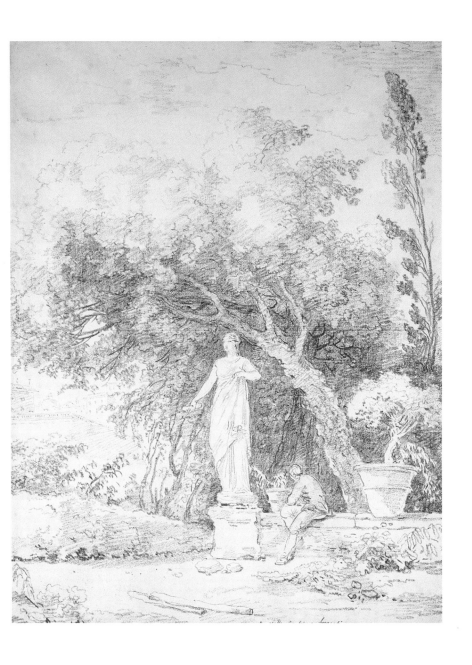

24 Charles-François de la Traverse *c.1726–c.1780*
A derelict bridge leading to a ruined wall
black chalk with pen and black ink and grey
wash
234 mm diam.
inscribed on the reverse: *C. D. L. T. Madrid Juillet*
1779/ Tandis que l'Espagne menaçoit Gibraltar
purchased, 1994
1994.53

Landscape drawings by La Traverse are lighter and
more decorative than his better known figure drawings
which are usually drawn with a vigorous pen and shad-
ed with a dark, expressive wash. The round format of
this drawing and the theme of the abandoned garden
are also found in the work of Hubert Robert whom La
Traverse knew in Rome but the manner of drawing with
spotted foliage and thin, lively washes, is closer to the
work of Fragonard. From Rome La Traverse moved to
Naples and then to Madrid when the king of Naples
inherited the throne of Spain. According to his first
biographer, he returned to France in 1778 although,
from the evidence of the note on the back of this draw-
ing, he appears to have been still in Madrid in the fol-
lowing July 'while Spain threatened Gibraltar'. It is not
clear why he should have dated his drawing by referring
to the siege of Gibraltar which began in earnest in the
summer of 1779 when the forces of Spain and France
combined against the English garrison.

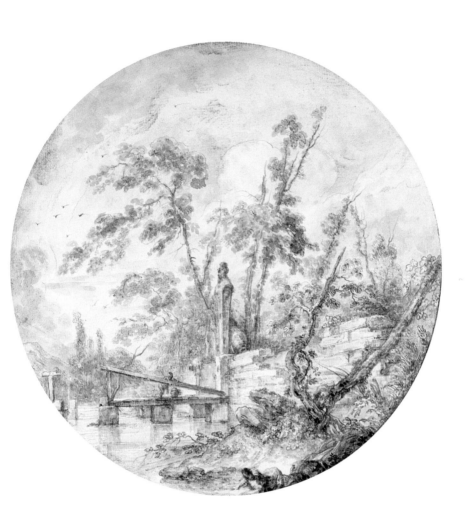

25 **Gabriel de Saint-Aubin** 1724–1780
A young man kneeling by a girl in a garden
black chalk touched with charcoal
178 × 122 mm
inscribed: *Mlle de la Gabelle . . le 19 juillet*
purchased, 1939
1939.81

Gabriel de Saint-Aubin was an insatiable draughtsman.
He did not paint much but drew subjects from the world
around him as well as imaginary compositions with a
restless freedom. The details of his drawings, added
with a delicate touch, dissolve into the fugitive effects of
stumped chalk and wash. He touched everything he
drew with an air of fantasy but dated and identified his
subjects with precision. The Mlle de la Gabelle of this
drawing has not been identified. The theme may have
been suggested to Saint-Aubin by Baudoin's *Gallant
gardener*, exhibited at the Salon of 1769 and twice
copied by Saint-Aubin onto the margin of his copy of
the catalogue.

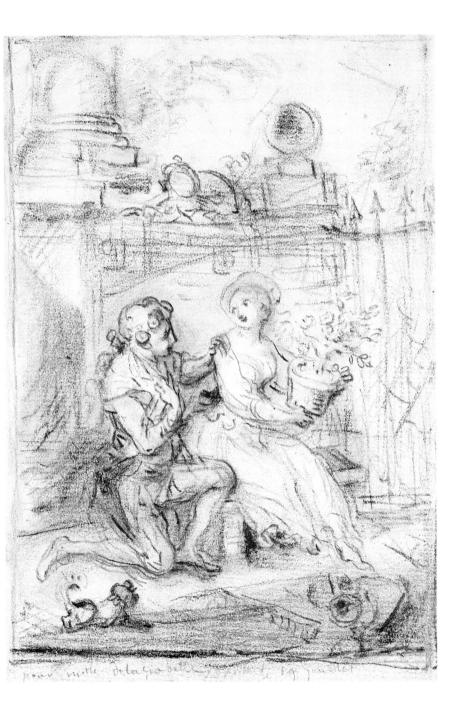

pour mette de la gio... ... le 29 juillet

26 Johann Georg Wille 1715–1808
Quarries at Menilmontant near Paris
pen and brown wash
170 × 216 mm
inscribed: *J.G.Wille*
purchased, 1938
1938.108

Johann Georg Wille was born in Germany but he came
to France at an early age and acquired his skill and his
reputation as an engraver while working for the French
print market. His studio in Paris became an important
meeting place for French and German artists, especially
for German engravers who followed him to Paris. He
was a notable collector of art, including Dutch art of the
seventeenth-century, and, like his friend, Greuze, and
others, he drew upon it as a source of ideas. His many
landscape drawings, in particular, are marked by his lik-
ing for the Dutch. These were largely drawn in the
course of annual sketching excursions into the country-
side, usually in autumn, accompanied by his son, his
friends and several of his pupils. According to a note on
the back, this drawing is a view of the quarries at Menil-
montant not far from Paris. Wille's diary which he kept
from 1759 to 1793, does not mention a visit to the quar-
ries but it records a visit by Henri, comte de Reuss, in
1776 when Wille reluctantly gave his visitor two draw-
ings in red chalk and bistre, made in Menilmontant in
1760. There is evidence of this in a drawing of the quar-
ry by Wille in the museum at Rouen which is dated Octo-
ber 1760 and is inscribed with an account of his
excursion to Menilmontant in the company of his wife.
Could one of the two figures talking animatedly to the
young artist be Mme Wille? The youth is probably either
her son or one of the artists who habitually accompa-
nied Wille on his sketching tours.

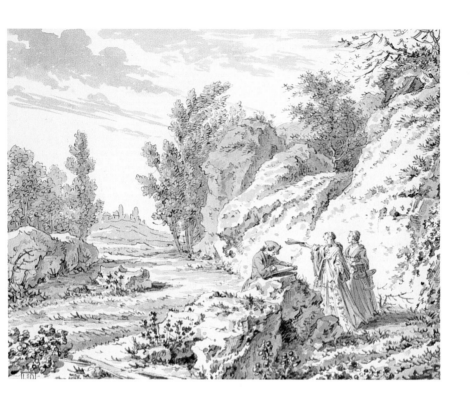

27 Jean-Baptiste Le Prince 1734–1781
Landscape with figures near a river
pen and brown ink with brown wash over
graphite
230 × 296 mm
inscribed: *Le Prince 1777*
purchased, 1980
1980.191

While travelling in Russia between 1758 and 1764, Le Prince developed his style and found a source of subjects for many drawings and paintings which he continued to produce on his return to France. His early drawings are marked by the lessons of Boucher but the influence of Dutch art is also evident in his landscapes and scenes of everyday life. From 1775 to 1781, he lived in the Plaine de Brie where the farmland of the region gave him subjects for a large number of drawings of landscapes with peasants. Most of these are dated 1776 or 1777. These landscapes form a group apart in Le Prince's work, mostly drawn, as this is, in graphite and pen with a sepia wash which has been added in a spotted manner, somewhat reminiscent of Fragonard's landscape drawings in the same period.

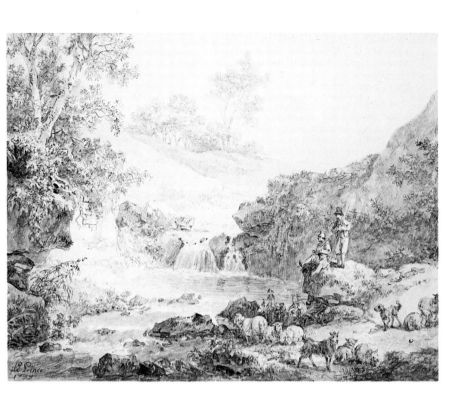

28 **Nicolas-Bernard Lépicié** 1735–1784
Head and shoulders of an old woman
black chalk and stump with touches of red chalk
in the face
137 × 122 mm
inscribed: *Lepicié del*
purchased, 1937
1937.211

Lépicié was an ambitious painter of large historical
compositions and a versatile draughtsman. Like his fel-
low academic painters, he worked extensively in the life
class, and was a skilled painter of the human figure. In
about 1771, he began to specialise in scenes from daily
life and it is for these that he is now best remembered.
The delicacy and precision of his portraits and genre
paintings are also characteristic of his many drawings.
Head studies, like this, are not uncommon in his work.
The artist usually began with a faint, rapid, accurate
contour in black chalk which he then delicately hatched
with a sharp point of red chalk, heightened with touch-
es of white chalk, and finally strengthened the contours
and salient features of the head with strokes of black
chalk. His models were often servants or other popular
types who appear frequently in his paintings in the last
ten years or so of his life. His technique is refined and he
drew his models with a sensitivity and sympathy which
are often lacking in the work of Greuze who painted
similar subjects in this period.

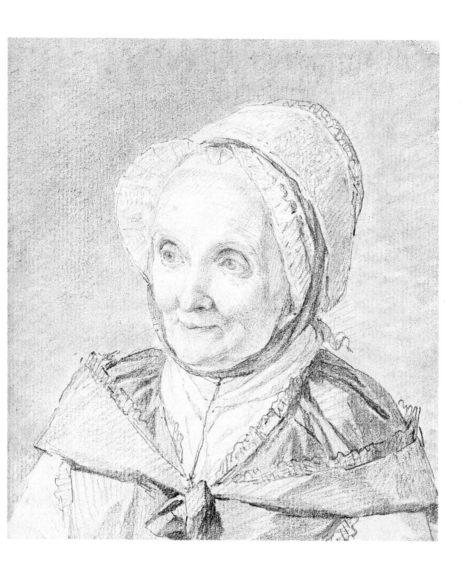

29 **Jean-Honoré Fragonard** 1732–1806
*Don Quixote and Sancho Panza ill-treated by
galley slaves*
black chalk with brush and brown wash on pale
beige paper
418 × 287 mm
purchased, 1949
1949.213

Fragonard trained with Boucher before he won the Rome Prize in 1756 and completed his education in Italy. Natoire, who was then director of the French Academy in Rome, seems to have encouraged Fragonard and his friend, Hubert Robert, to study Italian landscape and neither artist subsequently contributed much to the history of academic art. On return to Paris, Fragonard chose to earn his living by painting amorous and light-hearted scenes from mythology and contemporary life, decorative panels and portraits which he drew and painted with an easy virtuosity. He was also a spirited etcher and, like many of his contemporaries, drew illustrations for classic texts. In place of the neat precision commonly found in the work of the professional illustrators, Fragonard substituted a marvellous vivacity which would have been difficult to reproduce by engraving. This, perhaps, explains why so few of his illustrations were ever published. In 1789, the publisher, Pierre Didot, commissioned him to supply a series of drawings to illustrate the tales of La Fontaine but the outbreak of the French Revolution in 1789 undermined the market for expensive, illustrated books and when the book was published in 1795, Fragonard's contribution was severly reduced. During this period, he also prepared a series of large drawings to illustrate texts by Ariosto and Cervantes. These are drawn with an almost reckless vivacity and on a scale which did not conform to the standard illustrated editions of the eighteenth century and must have been prepared with a particularly sumptuous edition in mind. The circumstances in which he undertook these drawings are unknown and neither set was completed. Presumably, these were intended to be preliminary drawings from which more finished model drawings could have been made. The drawings for Cervante's adventures of Don Quixote are more vigorous than those illustrating Ariosto's *Orlando Furioso* and may be a little later. They are also less numerous. This drawing is typical of the set illustrating Cervante's text. It shows an episode from Book III in which the impetuous knight and his companion, Sancho Panza, have been stoned and abandoned by a company of prisoners whom they have just liberated.

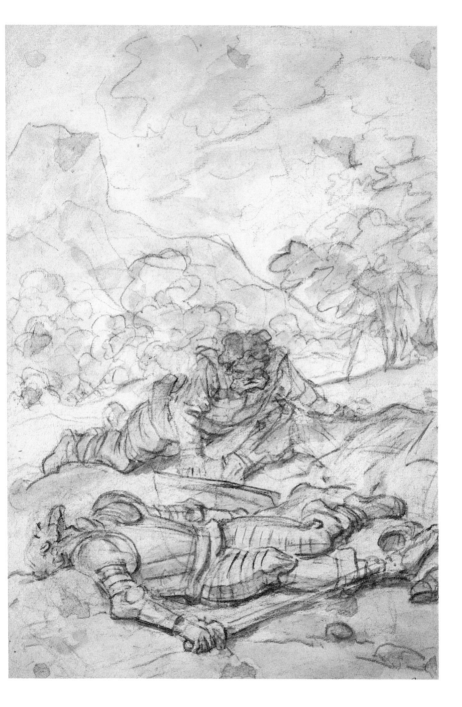

30 Charles-Dominique-Joseph Eisen 1720–1778
St Anne instructing the Virgin to read
black chalk with pen and black ink and water-
colour
363 × 259 mm
inscribed: *Ch.Eisen*
bequeathed by Francis Douce, 1834
1863.98

The importance of the illustrated book in eighteenth-
century France provided work for painters who turned
their hand to illustrating texts and for specialists, like
Gravelot, Moreau le Jeune, Cochin and Charles Eisen,
who worked almost exclusively for publishers of books
and prints. This picture of the Virgin learning to read at
her mother's knee might well have been intended to
illustrate a large Bible. The prominence of the carpen-
ter's tools in the foreground, however, makes it almost
certain that it was designed as a print for a charitable
society associated with the Paris carpenters whose feast
day was the 26th of July, St Anne's day, and whose
emblem was St Anne instructing the Virgin. No corre-
sponding print is known but prints like this, usually of
lesser quality, were regularly issued by the charitable
societies of Paris. Two prints of this type, designed by
Eisen for other confraternities, are known. At one time,
this drawing was paired with another (now lost) which
showed St Joseph sawing a plank while Christ mea-
sured another. The images were surely connected. As a
carpenter, St Joseph was held in special veneration by
woodworkers.

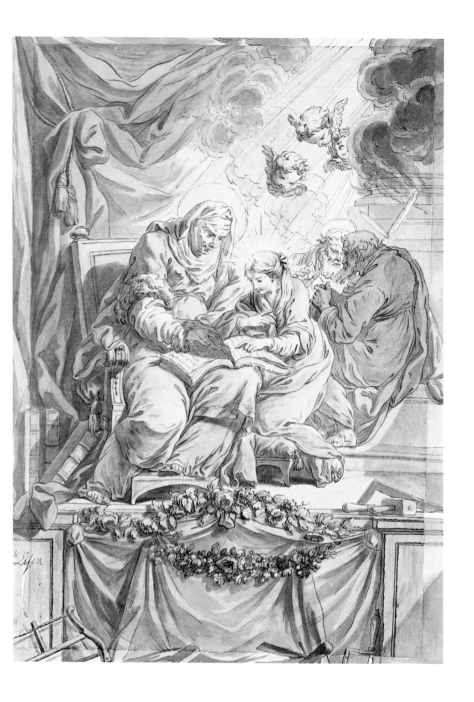

31 Louis Carrogis known as **Carmontelle**
1717–1806
The Comte du Lau on sentry duty
charcoal with black and red chalks and colour
washes
340 × 212 mm
inscribed on the mount: *Le jeune Comte Du Lau*
en faction devant Le Logis de son père
purchased, 1938
1938.117

In 1763, Carmontelle was appointed tutor to the son of
Louis-Philippe, the duc d'Orléans. He became an active
member of the Duke's household, writing plays, design-
ing gardens, devising lantern shows and filling his port-
folios with portrait drawings of the Duke's visitors and
employees at the Palais Royal in Paris and at the Duke's
country estate at Villers-Cotterets. These portrait draw-
ings were outlined rapidly and delicately in red or black
chalk and filled in with bright watercolour. Nearly all are
drawn in profile and provide a comprehensive image of
courtiers, servants and celebrities in the years before
the French Revolution. 750 of these portraits, mounted
in eleven albums, appeared at the sale of Carmontelle's
belongings in 1807. A later owner, apparently, mounted
many of them in green mounts with black and gold
framing lines and inscribed them with the names of
the sitters. Most were eventually bought by the duc
d'Aumale, Louis-Philippe's descendant, and are now in
the castle of Chantilly. Many others, including dupli-
cates, had been separated from the main collection by
this time and are now dispersed, including this engag-
ing portrait of the young comte du Lau. According to
the inscription on the mount, he is shown on sentry duty
outside his father's home. While he cannot be identified
with certainty, he was probably related to Jean-Louis-
Antoine, comte du Lau, who was also drawn by Car-
montelle. There is a second version of the Oxford
drawing in the collection at Chantilly. Neither is dated
but as the uniform which he wears was issued for the
first time in 1776, it must have been drawn between 1776
and the outbreak of the Revolution in 1789 when the
Orléans household was engulfed in the general catastro-
phe.

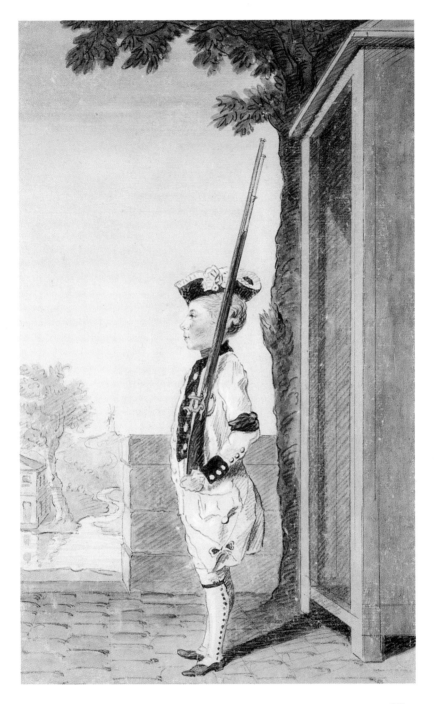

32 **Jean-Joseph Taillasson** 1745–1809
The penitent Magdalen
black chalk with pen and brown ink and brown
wash with traces of red chalk
212 × 197 mm
purchased, 1955
1955.69

Taillasson was a successful academic painter and theo-
rist who was somewhat overshadowed in his lifetime by
more famous contemporaries. This is a study for his
Magdalen in the desert, exhibited in 1784. A more
advanced study for the same painting was on the Paris
art market in 1991. The latter drawing introduces an
overturned jewellery box which reappears in the paint-
ing and was probably inspired by Lebrun's painting of
the Magdalen in the Carmelite church in Paris. Taillas-
son was particularly talented in the art of drawing and
painting expressive head studies in the tradition of
Lebrun and would have been attracted to the subject by
the opportunity it offered for depicting the effect of
strong, complex emotion on the face of the Magdalen. A
print of the penitent Magdalen after a painting by the
Flemish painter, Abraham Bloemaert, however, was the
immediate model. Taillasson was probably familiar with
this image from the 1719 edition of Gérard de Lairesse's
Principles of Drawing, where the print is reproduced as
a model for imitation.

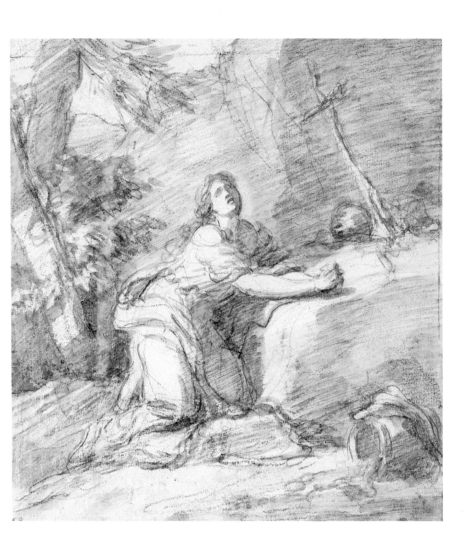

33 **Pierre-Paul Prud'hon** 1758–1823
Innocence preferring Love to Riches
black chalk, extensively stumped and heightened
with touches of white chalk on paper formerly
blue but now heavily discoloured
455 × 347 mm
inscribed: *R. Prud'hon*
purchased, 1952
1952.105

Although Prud'hon's training at the Dijon art school
distanced him somewhat from his Paris-trained col-
leagues, his art, like theirs, was based fundamentally on
life drawing. He studied the human figure and prepared
his compositions through beautifully crafted chalk stud-
ies of the nude, studied by the light of a studio lamp
which allowed him to model the figures in accentuated
light and shadow. The use of blue paper to which he was
introduced at Dijon allowed him to make effective use of
white chalk highlights. This is one of a group of draw-
ings made in connection with an allegorical painting,
now in the Hermitage, exhibited by his companion,
Constance Mayer, in 1804. Prud'hon seems to have
given her extensive help in preparing the painting. This,
however, is not a study but a copy made by Prud'hon as
a model for the printmaker, Barthélemy Roger, who
exhibited an engraving after the painting in 1810 and
again in 1814. The Oxford drawing differs from the
painting in a number of details but is a mirror image of
the print. The figure of Riches, offering her casket, is
based on an allegorical figure of England, devised by
Prud'hon for a medal design commemorating the Peace
of Amiens in 1802. The other two figures are based on
Canova's statue of *Cupid and Psyche* of 1797, now in the
Louvre.

34 Anne-Louis Girodet-Trioson 1767–1824
A rustic interior
black chalk
268 × 382 mm
purchased, 1985
1985.229

In the 1790s, Girodet supplied illustrations for editions of the classics, published by Pierre Didot. His controlled manner of drawing and the clarity and rigour of his compositions ideally suited the technique of engraving which was used in transferring the model drawings into prints. These magnificent books inspired Girodet to undertake an ambitious scheme of his own to illustrate a number of ancient classic texts, including Virgil's *Aeneid* and *Georgics*. The enterprise was in hand by 1811 but was unfinished when he died in 1824. By the time of his death, he had completed 171 illustrations for the *Aeneid* and four for the *Georgics*. These were not drawn with the elaborate shading which he used in the drawings for Didot but were executed in simple outline, imitating John Flaxman's recent illustrations for Dante's *Divine Comedy*. This style was inspired by ancient Greek vase painting and it was very fashionable in *c*.1800 when all things Greek and Roman were in vogue. It was also liked by publishers because it was much easier and less expensive to reproduce drawings in outline than it was to reproduce drawings with shading. After Girodet's death, many of these designs were published by his pupils in the form of lithographs which were even easier and less expensive than line engravings. This drawing is one of the four made for the *Georgics*. Like the other three, it relates to the first part of Virgil's poem which deals with winter. The artist presumably did not live long enough to complete drawings for the remaining seasons. The print from which this drawing was made was entitled: *Activities in a rustic interior during winter.* These activities are described in Virgil's text: 'a certain farmer spends the hours of night awake beside a winter's fire and with his sharp knife, shapes torches to a point. His wife meanwhile lightens her dreary work with song while she runs her noisy shuttle through her web or boils down the sweet juices of the grape and skims with leaves the froth from off the boiling cauldron.'

35 Anonymous *c.*1800
Portrait of a woman
black and white chalks, stumped and heightened
with white bodycolour and some white oil pig-
ment on buff paper
271 × 204 mm
purchased, 1984
1984.155

Portrait drawings of this type, neatly and extensively fin-
ished in stump and stippled with a sharp black chalk,
were a speciality of French artists from *c.*1790 to *c.*1810.
The technique was very widespread and may have been
inspired by engraved portraits or mezzotints. Isabey
commonly used it for his popular portraits but many
were the work of minor artists and are difficult to
attribute without a signature. This drawing may have
lost a signature or inscription when it was cut down
along three sides.

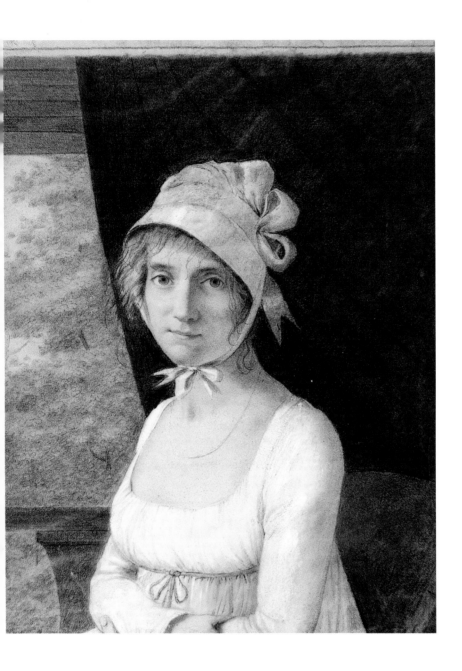

36 **Alexandre-Evariste Fragonard** 1780–1850
French troops crossing a wooden bridge
pen and brown ink, heightened with white body-
colour, with blue-green watercolour in the back-
ground
183 mm diam.
purchased, 1989
1989.13

From the evidence of his art, one would not readily
guess that Alexandre-Evariste was the son of Jean-Hon-
oré Fragonard. The older Fragonard was chiefly known
for the vivacity of his paintings while his son made his
reputation as a painstaking draughtsman. During the
Empire, he supplied many designs for book illustrations,
costumes, porcelain, public monuments and sculpture in
the fashionable neoclassical manner. His talent for
inventing simple, shallow ornament was ideally suited
for the task of supplying medal designs and he was
employed, along with about a dozen other artists, to
design medals commemorating the events of the first
Empire. The enterprise was supervised by Dominique
Vivant Denon, director of the Mint, who had completed
130 medals in the series by the time Napoleon was
defeated at Waterloo. One group of artists supplied the
designs which were then engraved and struck by spe-
cialists. As designs for medals are usually drawn life size
without added colour, it has been suggested that this
large coloured drawing might have been designed by
Fragonard as a preliminary model for official approval
before the final model was submitted. The design com-
memorates an episode in the battle of Essling in 1809
during the second Austrian campaign. It shows the
floating bridge built by French troops across the
Danube in place of the bridges destroyed by the Austri-
an rear-guard. Flood water cut the floating bridge in
half and only the timely capture of Essling allowed the
French to make an orderly retreat. In 1811, the drawings
for the medals commemorating the campaign were sub-
mitted to the comte Daru who had been appointed by
Napoleon to approve the designs. Daru sent Denon a list
of detailed criticisms which included a particular objec-
tion that Fragonard's design for the Essling medal was
difficult to understand without an explanation. In reply-
ing to Daru, Denon explained that the soldiers with two
standards represented the division of the troops into
two sections by the waters of the Danube. The idea, as
Daru observed, is not self-explanatory.

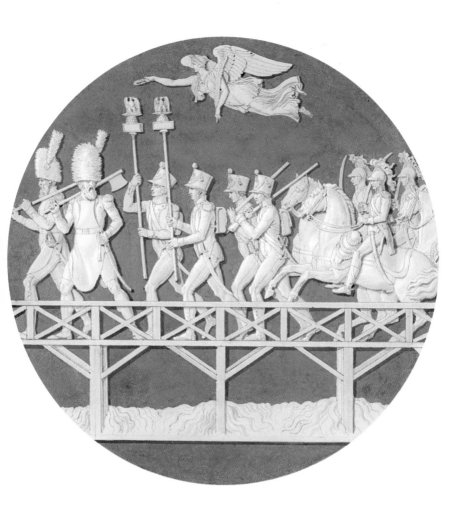

37 Jean-Auguste-Dominique Ingres 1780–1867

Jean-François-Antoine Forest
graphite
315 × 224 mm
inscribed: *Ingres Firense 1823*
presented by the National Art Collections Fund,
1936
1936.223

Ingres, like his hero Raphael, learned the art of drawing from his father. In his extreme youth, he used red chalk, but this was already going out of fashion and most of his abundant drawings were executed in the artificial graphite invented by Nicolas Conté in the 1790s as a cheap and accessible alternative to natural graphite. The graphite pencil gave Ingres a sharp, flexible instrument which he handled with an unerring touch. At the end of 1810, when his scholarship at the Rome Academy ran out, he remained in Rome working for the French administration and supplementing his income by making pencil portraits of friends, colleagues and officials. When the French left after the fall of the Empire in 1815, pencil portraits became his livelihood. Many represent English visitors whom he drew with astonishing assurance and with the simplest of means; others are of friends and colleagues who are drawn with a more summary touch and sometimes with signs of more visible affection. This portrait, drawn in Florence in 1823, was one of the last drawings of this kind before he returned to France. It represents a little-known architect from Lyons who was in Rome in 1823 and who had presumably passed through Florence where Ingres had gone in 1821 in the hope of finding new patrons. Apart from this drawing, nothing is known about their relationship but they were surely friends and the drawing must commemorate this. The outline of the coat and hat is drawn with a panache which is less marked in most of the portraits which he made of the tourists in this period. He wears an outdoor coat and carries a pencil and portfolio, and is perhaps about to go on a sketching excursion into the Tuscan countryside. Ingres began his portraits with a rapid, faint, accurate sketch which he later strengthened with the pencil. The head is particularly carefully touched with a dark, soft pencil which serves to emphasise the sitter's face. He has a lively expression as if he has been momentarily stopped on the point of going out.

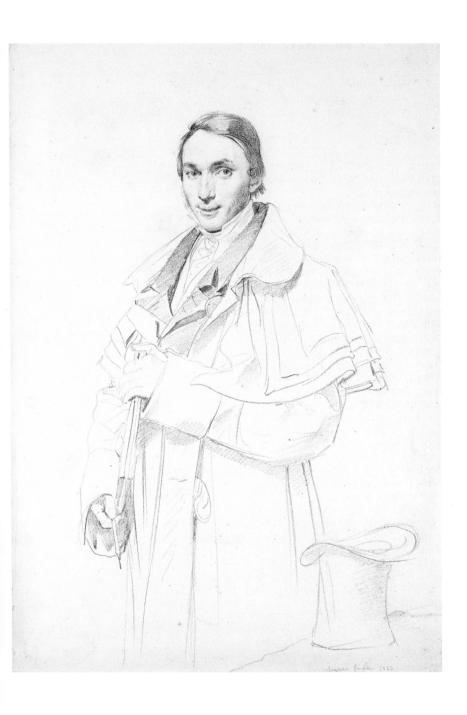

38 **Hippolyte-Jean Flandrin** 1809–1864
Portrait of a seated youth
graphite
288 × 228 mm
inscribed: *A son cher oncle et sa chère tante/*
Onésime Ancelot/ Hippolyte Flandrin/ 1843
purchased, 1994
1994.37

The linear style of Flandrin's drawings was influenced by Ingres who was Flandrin's teacher from 1829 to 1833 and again in Rome from 1835 to 1837 when Flandrin was a student at the Academy and Ingres was director. Flandrin's sense of contour which is dryer and more deliberate than Ingres's contributed to his greatness as a mural painter. This portrait is superficially like the drawings in Ingres's series of graphite portraits but the character is quite dissimilar. Flandrin never tries to imitate Ingres's fleeting lines but moves his pencil round the figure, following a light outline, with a slow, even touch and delicately models the clasped hands with neat, curved shading. The head is tenderly observed with a touch of the serious. The youth who is identified in the inscription as Onésime Ancelot, sat for his portrait in 1843, the year of Flandrin's marriage to Aimée Ancelot. There must be a family link but the sitter is otherwise unidentified.

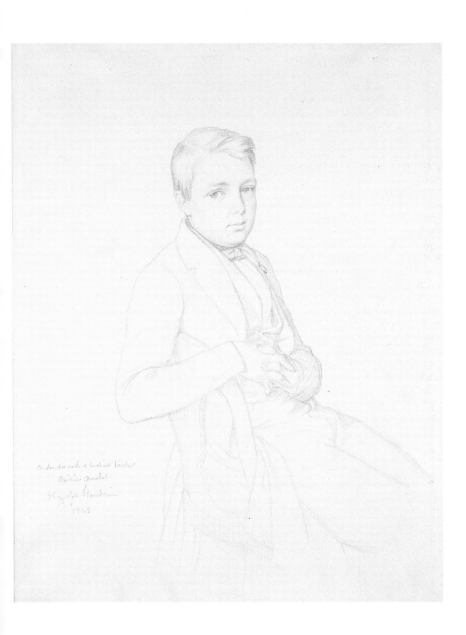

83

39 **Carl Ernest Rodolf Heinrich Salem Lehmann**
1814–1882
A sheet of costume studies
black crayon
302 × 184 mm
inscribed: *7 avril 59*; and stamped: *Henri Lehmann*
purchased, 1985
1985.199

Lehmann was born in Holstein but took French citizenship in 1846 and had a long, successful career as a painter and teacher in France. He went to Ingres's studio in 1831 and, like many of Ingres's pupils, he became a talented draughtsman. He developed a distinctive manner of drawing with dark graphite and abrupt shadows in keeping with his liking for romantic effects of light and shade in his paintings. Like other pupils of Ingres, he was drawn into the programmes of decoration in the churches and official buildings of Paris. This involved a process of extensive preparatory drawing which Lehmann executed in the traditional succession, beginning with a rough draft of his composition and graduating through figures of the nude and studies of drapery to the final design which he transferred to the wall by means of a 'cartoon', an enlarged version of the final design, drawn full-scale. The draped figure in this drawing was intended for the figure of an angel, high up in a huge mural on the theme of The Lord's Prayer, commissioned for the east transept of the recently completed church of Ste-Clotilde in Paris. Lehmann received the commission in 1854. This drapery study was drawn on 7 April 1859, the day after Lehmann dated the nude study of the same figure. When the mural was completed, Lehmann was displeased with the effect, destroyed the work and refunded the fee.

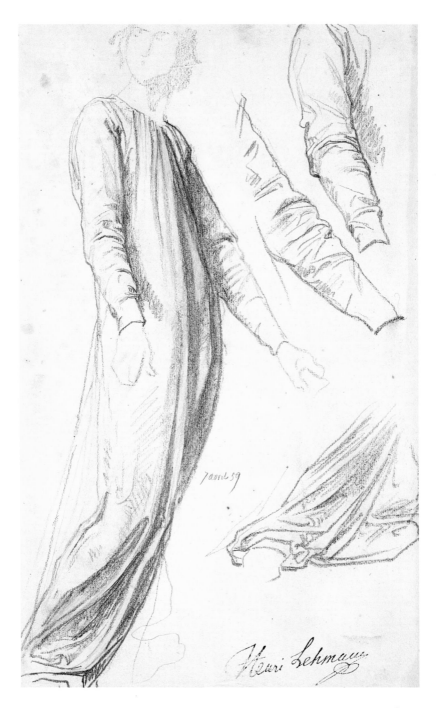

7 avril 59

Henri Lehmann

40 **Hilaire-Germain-Edgar Degas** 1834–1917
A seated jockey facing right
charcoal, slightly rubbed, with some unrelated
lines in blue pencil on grey, discoloured paper
480 × 310 mm
bequeathed by John Bryson, 1977
1977.27

From his master, Louis Lamothe, Degas learned the
value of drawing in the tradition of Ingres. He did not
imitate Ingres's manner but his mastery of drawing was
based on Ingres's principles. During a brief meeting,
Ingres encouraged him to draw: 'make lines, many
lines, and you will become a good artist'. There is a
great variation and experiment in Degas's drawings but
all of them are based on the primacy of line. Like Ingres,
he defined form chiefly by means of contour. From
Ingres, also, via his training with Lamothe, he learned
the importance of 'learning to see nature' by extensive
drawing from the human figure. Degas did not attempt
the Rome Prize but he studied at the Rome Academy,
nevertheless, as a member of the group of French artists
in Rome who had access to the Academy's life class. He
did not make a sensational début and left many of his
early compositions unfinished but in the course of work-
ing on his early projects, he refined and developed his
skill in figure drawing which enabled him to draw and
paint the jockeys, ballet-dancers and bathers which
became his main subjects once his ambition to paint a
historical 'machine' had faded. His first major race-
course painting, the *Gentlemen Jockeys* of 1862,
includes a figure very similar to the jockey in this study
but the thick, impulsive charcoal lines of the drawing
date it clearly to a later period. Degas habitually reused
a good pose and this study was probably made in about
1882 in connection with one of two pastel drawings of a
racecourse in which the Oxford jockey appears promi-
nently. It is tempting to think that this vivacious drawing
with its hasty revisions and accidental smudges was
drawn at the races but the link with the earlier picture
probably confirms that it was drawn from a posed
model.

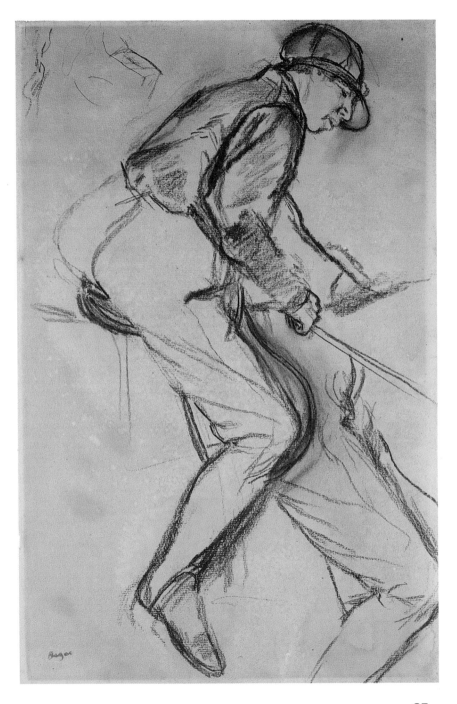

41 William Adolphe Bouguereau 1825–1905
A North African Girl selling pomegranates
graphite heightened with white chalk on grey
paper
296 × 247 mm
inscribed: *W. Bouguereau*
purchased, 1965
1965.1

Like many of the best French draughtsmen, Bouguereau
won a state scholarship to Rome. On return to Paris in
1854 he seemed cut out to become a major force in aca-
demic art but made his career instead painting idealised
peasant subjects for an international clientèle of art col-
lectors while still painting the occasional 'large mach-
ine' – as ambitious academic paintings were known –
for the annual exhibitions. The success of his work rest-
ed not only on the suave virtuosity of his painting tech-
nique but on his impeccable skill in the art of figure
drawing which was appealing in itself and was also easy
to reproduce on porcelain, in photographs and in prints.
This drawing corresponds to a painting of 1875 which
Bouguereau's dealer sold to an American colleague who
seems to have sold it on to the King of Holland but at this
stage, it disappears and its whereabouts are not now
known. The drawing is one of a type of finished, detailed
model drawings, drawn with a faultless line and a deli-
cacy of touch, which the artist followed closely when
completing the painting. The theme belongs to a small
group of North African subjects which Bouguereau
treated from *c.*1870 to *c.*1880. He does not seem to have
visited North Africa and posed these compositions
using Italian or North African models who were avail-
able in Paris. The oriental theme was very fashionable at
the time and Bouguereau would not have needed to go
far to find his materials.

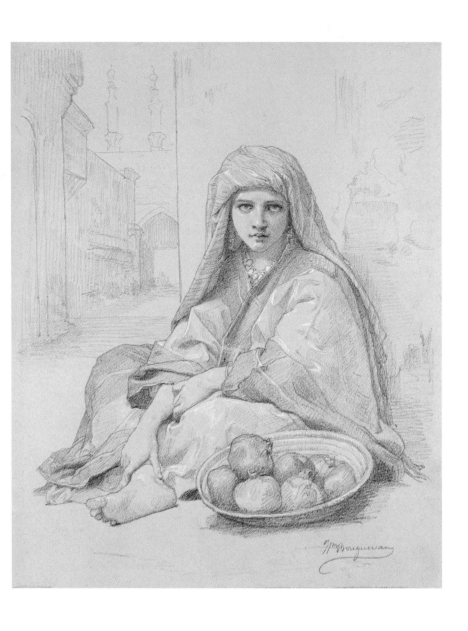

42 Ferdinand-Eugène-Victor Delacroix 1798–1863

A sheet of studies
graphite
203 × 290 mm
stamped: *Delacroix*
bequeathed by Dr Grete Ring, 1954
1954.70.15

Despite executing a huge quantity of drawings, Delacroix rarely made drawings for their own sake. His drawings are, on the whole, severely practical. He was taught by Pierre Guérin, one of the most prominent academic teachers of the early nineteenth century, and his manner of preparing his paintings through preliminary sketches and figure drawings was in the academic tradition. He was aware of the risk of losing the spark of inspiration during the routine stages of preparatory work and his studies are usually less worked up than those of Guérin and the artists of Guérin's generation. His pen drawings, in particular, often have a bravura which anticipates the energy of the finished work. This sheet, however, has a delicacy which is closer to the effects of his early lithographs. The faint study of horsemen in upper right appears to be a study for a lithograph illustrating an episode from Goethe's play, *Goetz von Berlichingen*. No print relates to the couple who appear walking on the left and again in the lower right, but they correspond well enough with another episode in the play in which Weislingen, holding the hand of Adelaide von Wolfenden, is interrupted by the entry of a page. Delacroix's prints after Goethe's play were published in 1836–1843 but this drawing must be earlier. The neat, dense work with the pencil is closer to his work of the late 1820s than it is to the more open, schematic drawings of the 1830s and 40s. There is a note-book in the Louvre of *c.*1827 in which Delacroix has listed subjects from *Goetz von Berlichingen*. It seems likely that this drawing dates from the same time as the list. In the 1820s, Delacroix made a number of copies of figures from German sixteenth-century prints which he probably consulted while collecting material for his illustrations of Goethe. The figure of Adelaide, in particular, seems to show some knowledge of similar costumed figures in the work of the German printmakers.

43 Gabriel-Alexandre Decamps 1803–1860
A Turkish merchant
watercolour and bodycolour with varnish
239 × 182 mm
inscribed: *Decamps*
purchased, 1963
1963.7

There is an obvious kinship between Decamps's use of thick, dark pigment in his paintings and his manner of drawing with charcoal, black chalk and dense gouache. This drawing of an oriental street-merchant is finished like a small painting with added gum arabic which gives gloss and body to the pigment. The technique was probably inspired by Bonington's gouache paintings of 1826–8. There is also some similarity with Delacroix's small oils. All three artists shared a liking for oriental subjects in the 1820s which they studied, initially, at second hand. In 1828, Decamps set out for Asia Minor and North Africa and became a specialist in paintings inspired by the Near East. His oriental pictures, based on his experience of his travels, were much admired. He was equally popular as an animal painter and executed a large number of worked-up watercolours like *A Turkish merchant* for sale to dealers and collectors. *A Turkish merchant* was probably painted in the 1830s in Paris, using the accessories which he had accumulated on his travels. His sale of studio props in 1853 included several oriental sabres and two silver-mounted Albanian pistols which may have provided him with the models for the merchant's stock.

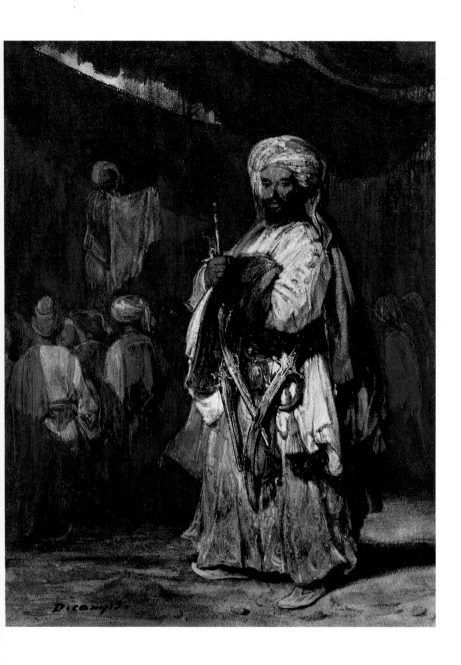

44 Jean-François Millet 1814–1875
A path through woods to a thatched cottage
graphite with pen and brown ink
174 × 235 mm
inscribed: *Dyane* (twice) and stamped: *J.F.M.*
bequeathed by Dr Grete Ring, 1954
1954.70.51

In 1849, Millet moved from Paris and settled in the village of Barbizon in the forest of Fontainebleau where he spent the rest of his life finding his subjects among the labourers who worked in the forest and in the nearby fields. Landscape was at first a secondary interest but from the mid-1860s, it became more important to him as a subject in its own right. A visit to Vichy in the Auvergne in the summer of 1866 for the sake of his wife's health, gave him an opportunity to make many drawings of the countryside which he recorded with a light black chalk, later strengthened with a thin, broken pen line and sparse touches of watercolour. The hilly countryside of the Auvergne which was entirely different from the flat plain in the region of Fontainebleau, gave him a stock of varied motifs which he later transferred into pastels and paintings when he returned to Barbizon. The inscription on this drawing identifies the site as the village of Dyane, situated near Mont-Dore in the Auvergne, which Millet visited during his visit to Vichy in 1866. The site was particularly picturesque and the Millets spent a week there exploring the district.

Dyane

Dyane

45 **Jean-Baptiste-Camille Corot** 1796–1875
Landscape with trees, pond and cottages
charcoal with stumping and erasures on dis-
coloured paper
357 × 437 mm
bequeathed by Mrs F.W.Weldon, 1937
1937.19

Corot's masters, the landscape painters Achille-Etna
Michallon and Jean-Victor Bertin, taught him the impor-
tance of painting out of doors but stressed the greater
value of work done in the studio where invention and
poetry could be combined with the effects of nature.
Corot's oil sketches, painted out of doors in Italy and
France, as well as his many drawings in pen and pencil,
are in this tradition. Younger painters tended to value
Corot's nature studies as works of art and modern taste,
in general, prefers them to his historical pictures. Corot
would not have been amused by the judgement of pos-
terity. While nineteenth-century French landscape
painting increasingly narrowed the gap between the
nature study and the finished work, Corot never lost his
belief that great art is made by poetic recreation in the
studio. In the 1850s, the idealising tendency in his art
became more pronounced, the light in his pictures
became more diffuse and the details blurred and simpli-
fied. His drawing style also became more generalised
and less linear. This large drawing seems to be a study
for a painting dating from the 1850s. The smudged effect
of charcoal resembles the diffused effects of light in his
later paintings, seen as if through a veil of gauze, elimi-
nating distracting detail.

46 Jean-Desiré-Gustave Courbet 1819–1877

A young boy holding a basket of stones
black chalk extensively stumped
295 × 211 mm
inscribed: *G. Courbet*
purchased with contributions from the National
Art Collections Fund, the Museums and Galleries
Commission/V.& A. Purchase Grant Fund and
the Friends of the Ashmolean through David
Carritt Ltd, 1998
1998.3

Drawings by Courbet are not common. He rarely prepared his paintings with preliminary drawings and, with the exception of his landscape sketches, most of his known drawings were either drawn for their own sake or for reproduction in lithographs. The roadmender in this drawing was copied by the artist from one of the two figures in one of his most famous works, *The Roadmenders*, as the model for a print. The painting was exhibited in 1850 but as the print was not issued until 1865, the drawing must date from fifteen years after the painting. Like his manner of painting, Courbet's style of drawing is direct and broad. His thick, black crayon does not always clearly define the details. The boy's sack is not easy to distinguish from the shadow, the stones in his basket are imprecisely indicated and the background, which has been rubbed over to give an even grey tone, merges into the foreground. This manner of drawing would not have been of much use as a model for a painting where the need is for detail and for solutions to problems of form and composition but it was well adapted to the technique of lithography, a method of printing from a polished stone on which the artist or his printmaker has drawn or transferred the design with a greasy, water-resistant crayon. In this case, the print was made by the more complex process of transfer lithography. There are similarities between Courbet's drawings and those of Bonvin, Daumier, Decamps, Gigoux, Cals and Troyon who were all skilled in the art of tone drawing. They form a loosely associated group of artists – including several lithographers – who were either trained outside the great teaching studios of Paris or were only minimally involved.

47 Ignace-Henri Fantin-Latour 1836–1904
A woman sewing
charcoal with stumping and erasures, touched
with white chalk
306 × 295 mm
inscribed: *1857*
purchased, 1935
1935.127

After a brief and unsuccessful attempt to obtain basic
academic skills at the Ecole des Beaux-Arts in Paris,
Fantin left to complete his education by studying at the
Louvre. François Bonvin whom he met in 1853 probably
encouraged him to study contemporary life. Subjects of
modern life also became an interest for his other friends,
Manet, Whistler, Courbet and Baudelaire, but this was
only one strand of Fantin's art and all his work of this
kind can be seen as an extension of the art of portrait
painting. From 1855 to 1861, he used his sisters as mod-
els for a group of paintings, prints and drawings which
are neither conventional portraits nor anecdotal pic-
tures of domestic life. There are parallels between these
images and Bonvin's paintings and drawings of ser-
vants absorbed in work. In her biography of Fantin, the
artist's wife identified the Oxford drawing as a picture of
Nathalie Fantin. It is not always easy to distinguish one
sister from another in Fantin's drawings, but as a rule,
he drew Nathalie in the act of sewing or embroidering
whereas he more often drew Marie Fantin absorbed in
reading. There is little contour in this drawing. Widely
spaced hatched and cross hatched lines of charcoal are
used to reinforce areas of half tone which cut across the
figure and partly cancel the contour while form is sug-
gested with carefully juxtaposed patches of light and
dark.

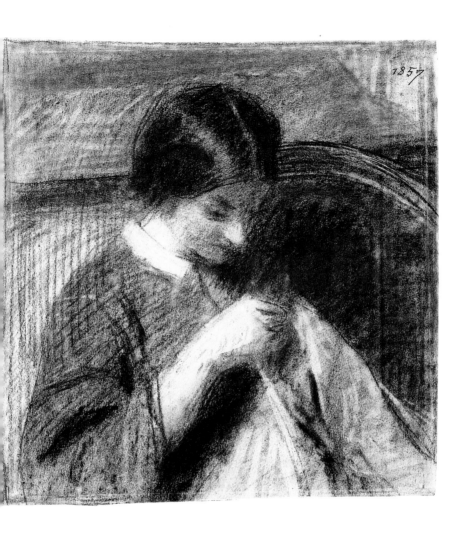

48 **Edouard Manet** 1832–1883
Lunch on the Grass
black chalk with pen and black ink and water-
colour
406 × 476 mm
inscribed: *Ed manet*
presented by H.M.Government from the estate
of Richard and Sophie Walzer in accordance
with their wishes, 1980
1980.83

Manet did not develop his compositions with many preparatory drawings but seems to have preferred to work directly on the canvas, correcting as he went along. It was at one time supposed that this watercolour was a final study for the famous painting of 1863 but it is now generally believed to be a copy by Manet after the painting, perhaps a tracing from a photograph. There is a mechanical and fragmentary character to the contours in black chalk which certainly has the appearance of a tracing and the correspondence with the painting seems far too close to have been drawn free hand. Several of Manet's watercolour copies of his paintings were done for prints and this seems the best explanation for this drawing. Manet, however, does not seem to have made a print of this composition. The drawing is unfinished, particularly on the left side from which a strip has been cut off, and it may be that Manet abandoned the project. The image has become so familiar that it is difficult nowadays to see it though the eyes of Manet's contemporaries. It is unquestionably odd. Even the perceptive critic, Théophile Thoré, was dismayed: 'I fail to see what can have induced a distinguished and intelligent artist to adopt such an absurd composition'. Thoré failed to see – what is now universally known – that Manet had adopted a group from a print by Marcantonio Raimondi after Raphael's *Judgement of Paris*. The source was impeccable but it is unlikely that recognising the source would have mollified the critics.

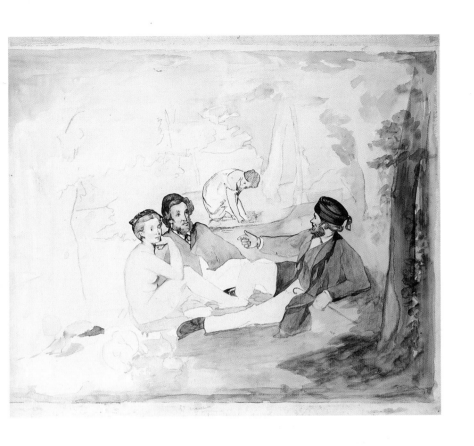

49 Berthe Morisot 1841–1895
Study of a seated girl
graphite
280 × 200 mm
stamped: *B.M*
purchased, 1934
1934.285

In the nineteenth century, the Louvre was a meeting point for the many artists who went there to make copies of the Old Masters. Fantin-Latour met both Manet and Berthe Morisot while all three were copying in the Louvre. Fantin then introduced Morisot to Manet and hence into the band of painters round Manet. Modern life was a shared interest among the artists in this circle. Like Fantin, Berthe Morisot found her subjects of modern life in her immediate friends and family. Her daughter Julie became a favourite model. Her lively manner owes something to the example of Manet – who became her brother-in-law when she married Eugène Manet – but she painted with a lighter and more spirited touch and with a greater interest in landscape. Like several of her fellow Impressionists, she worked extensively in pastel and watercolour. In the 1870s, she tended to work directly on the canvas with little preliminary work but, like Renoir, began to prepare her pictures in the 1880s with studies and sketches. This drawing of a seated girl is a study for a watercolour in the Philadelphia Museum of Art to which it closely corresponds. The chair reappears in a watercolour painted in Morisot's house in the rue Weber where she moved after the death of Eugène in 1892. The sitter cannot be identified with certainty but she must be one of a number of girls – including Julie Manet – who posed for the artist in the rue Weber in 1893–4.

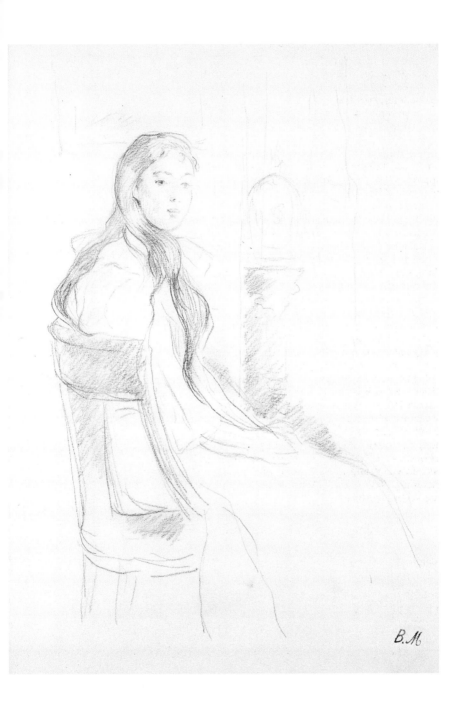

105

50 James Jacques Joseph Tissot 1836–1902
A woman standing in outdoor costume
watercolour and bodycolour over black chalk on
faded blue paper
416 × 253 mm
purchased, 1942
1942.109

Tissot belonged to a group of artists in Paris in the 1860s who turned away from historical themes and began to specialise in subjects from modern life. In 1871, following the violent overthrow of the Paris Commune, he fled to London where he found a wealth of new subjects. Between 1871 and 1873, he made several gouache studies of women in contemporary dress. Most of the ten known studies of this type can be linked to compositions which were painted and exhibited in London. The use of blue paper allowed him to use extensive white gouache which would have been less effective on cream or off-white. Gouache on blue paper was also commonly used by the illustrators of *Vanity Fair*, and Tissot may have acquired his taste for this technique between the late 1860s and 1873 while working for the magazine. This figure appears almost unchanged in *The Captain and his Mate*, a painting of 1873. She glances sideways towards the captain and his companion, seated on the left side of the composition. There is a hint of anecdote but it is not explicit.

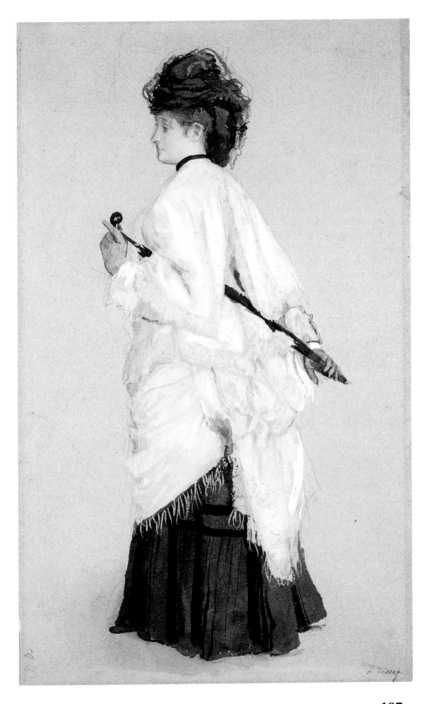

51 Paul Cézanne 1839–1906
Still life of peaches and figs
graphite with watercolours
198 × 307 mm
presented by H.M.Government from the estate
of Richard and Sophie Walzer in accordance
with their wishes, 1980
1980.82

Cézanne took up watercolour seriously in 1866–7. His early watercolours tend to be dense and rough in keeping with his work in oil but the lightness of the medium may have acted as a check on the thick, clumsy application of dark paint which is a feature of the oils of the 1860s. From the early 1870s, Cézanne's oil paintings and watercolours developed in tandem towards the luminosity and thin, carefully structured areas of colour which are characteristic of his work in the 1890s. The extensive pencil lines underlying the watercolour in this still life do not do much more than mark out the composition which depends almost entirely for its effect on the skilfully applied areas of colour and on the balance between the coloured areas and the blank paper. The forms are minimal but not unimportant and are defined by layers of luminous colour varying in density. In the 1890s, Cézanne began to use watercolour to dissolve his forms but here he uses it to define form and for this reason, a date before 1890 has been suggested. It may date between 1885 and 1890. The plate on which the fruit is placed is seen in perspective but the reduction of the sense of space and the flattened image makes the eye read this as an oval on the surface of the paper. It has been suggested that the sheet of paper was once twice as large but has been cut in half to conform to the narrow oblong of the image. This format is also found in his oil paintings of fruit which date mostly from the mid 1870s to the mid 1880s.

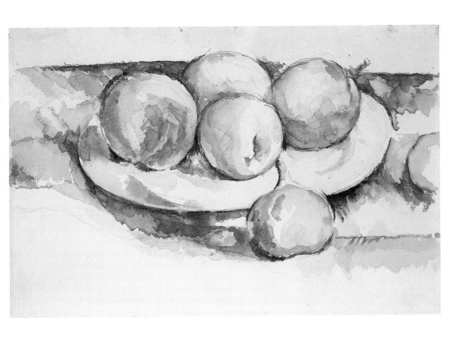

52 Jacob-Abraham-Camille Pissarro 1830–1903
A market scene
black crayon with pen and black ink, grey wash
and white bodycolour on tracing paper
319 × 225 mm
presented anonymously, 1989
1989.120

None of the Impressionists – apart from Degas – made
as many drawings as Pissarro. During his early travels
in Venezuela from 1853 to 1855, he filled his notebooks
and portfolios with views and picturesque detail. Later,
when he had settled in France and took Corot as his
mentor, he studied landscape chiefly through drawing.
In the 1870s, when he became more aware of Millet's
work, he spent more time drawing the human figure,
simplifying the forms and eliminating the detail. In the
1880s and 1890s, Pissarro's figure drawings become
very common. Few of these relate directly to his paint-
ings but many were designed as models for woodcuts
by his son, Lucien, who had settled in London in 1890.
Because they were intended as patterns for his son, they
were executed more carefully than the great majority of
his drawings. This composition was intended for a
series of prints on the theme of farm labour. The clear,
heavy contours – which Camille compared to the leaded
outlines of stained glass – anticipate the lines cut in
ridges in relief on the surface of the block. The composi-
tion developed through stages of drawing, beginning as
an oblong image, and then altered to the present upright
format for the sake of introducing more recession in the
background. This detail was the subject of a separate
drawing. Pissarro was dissatisfied with the standing
man on the right and made an improved study. He cov-
ered the previous figure with white gouache and copied
the improved figure onto the place. Camille mentioned
this change in a letter to Lucien when sending an uncor-
rected tracing for his opinion. The design, in its correct-
ed form, was transferred to the block but it was never
cut.

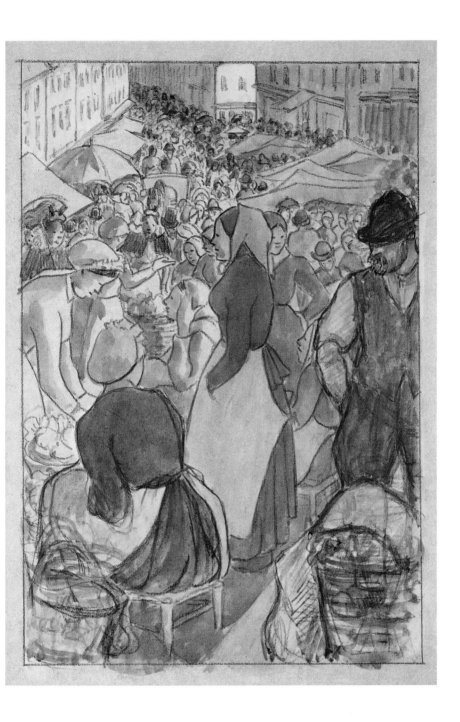

Further reading

Richard Brettell and Christopher Lloyd *A Catalogue of Drawings by Camille Pissarro in the Ashmolean Museum, Oxford*, Oxford 1980.

Colin Harrison *Line and Colour–19th Century French Drawings from the Collection of the Ashmolean Museum, Oxford*, Tokyo Station Gallery, June 6–July 1992.

Jon Whiteley *Catalogue of the Collection of Drawings in the Ashmolean Museum, volume VI, French Ornament Drawings of the Sixteenth Century*, Oxford 1996.

Jon Whiteley *Catalogue of the Collection of Drawings in the Ashmolean Museum, volume VII, French School*, Oxford 2000, 2 vols.